PICTURES, PATENTS, MONKEYS, AND MORE...ON COLLECTING

Artworks from the Robert J. Shiffler Foundation's art collection, Greenville, Ohio, by Janine Antoni, Karen Finley, Four Walls, Felix Gonzalez-Torres, Gregory Green, Perry Hoberman, Charles LeDray, Christian Marclay, Joel Otterson, Paul Ramirez-Jonas, Jason Rhoades, Matthew Ritchie, Kay Rosen, Lorna Simpson, Annie Sprinkle, Jessica Stockholder, Tony Tasset, Rirkrit Tiravanija, Brian Tolle, Carrie Mae Weems, Sue Williams, and Fred Wilson

Patent models from the National Museum of American History, Smithsonian Institution, Washington, D.C.

Sock monkeys from a private collection

Pictures, Patents, Monkeys, and More...

ON COLLECTING

Essays by
INGRID SCHAFFNER, Guest Curator
FRED WILSON
WERNER MUENSTERBERGER

INDEPENDENT CURATORS INTERNATIONAL
New York

Published to accompany the traveling exhibition *Pictures, Patents, Monkeys, and More…On Collecting*, organized and circulated by Independent Curators International (ICI), New York. Guest curator for the exhibition is Ingrid Schaffner.

EXHIBITION ITINERARY
(at the time of publication)

Western Gallery
Western Washington University
Bellingham, Washington
January 19–March 10, 2001

John Michael Kohler Arts Center
Sheboygan, Wisconsin
August 12–October 21, 2001

Akron Art Museum
Akron, Ohio
November 17, 2001–February 24, 2002

Fuller Museum of Art
Brockton, Massachusetts
June 1–August 18, 2002

Institute of Contemporary Art
University of Pennsylvania
Philadelphia, Pennsylvania
September 15–November 10, 2002

Pittsburgh Center for the Arts
Pittsburgh, Pennsylvania
January 18–March 16, 2003

Library of Congress Catalog Number: 00 140024
ISBN: 0-916365-59-X

Editor: Lisa Cohen
Design: Barbara Glauber & Beverly Joel/Heavy Meta
Printed in Germany by Cantz.

LENDERS TO THE EXHIBITION
The exhibition draws on three distinct collections: the collection of contemporary art of the Robert Shiffler Foundation, Greenville, Ohio; the National Museum of American History, Smithsonian Institution, Washington, D.C. for their collection of nineteenth-century patent models; and a private New York-based collection of stuffed sock monkey toys. At each venue, the exhibition is supplemented by a fourth collection, chosen by the presenting institution.

In keeping with the concept of the exhibition, the designers of the book have contributed elements from their own collection of typographical flourishes.

ICI's 25th Anniversary
1975–2000

© 2001 Independent Curators International (ICI)
799 Broadway, Suite 205
New York, NY 10003
Phone: 212-254-8200 Fax: 212-477-4781
www.ici-exhibitions.org

PHOTO CREDITS
Courtesy Basilico Fine Arts, p. 19; courtesy Brian Multiples, p. 22; D. James Dee, p. 12, 18, 27, 31; Ron Forth, p. 14, 26, 32; Four Walls, p. 21; courtesy Christopher Grimes Gallery, Santa Monica, CA, p. 30; courtesy Rona Hoffman Gallery, Chicago, p. 20; courtesy Postmasters, Inc., New York, p. 20; courtesy Shiffler Foundation, Ohio, p. 15, 18, 22, 23, 24, 27; courtesy Carl Solway Gallery, Cincinnatti, OH, p. 28; courtesy Sotheby's, p. 11; Richard Strauss, p. 46, 47, 48, 49, 50, 51, 52, courtesy National Museum of American History, the Smithsonian Institution, Washington, D.C.; Arne Svenson, p. 57, 58, 59, 60, 61, 62, 63, 64; Hugh Talman, p. 45, courtesy National Museum of American History, the Smithsonian Institution, Washington, D.C.; courtesy 303 Gallery, New York, p. 29; Tony Walsh, p. 13, 18, 25

Cover: Christian Marclay, *Chorus*, 1988; Two Sock Monkeys; Windmill, 1878; and Dog-Powered Treadmill, 1878

contents

Pictures, Patents, Monkeys and More…On Collecting is ICI's first exhibition to explicitly address the subject of collecting. In doing so, it examines the very nature of art and how art works differ from other objects. Collecting is not only a prime function of most museums, it is also of broad appeal to individuals, confirmed of late by the fact that the *Antiques Road Show* has become one of public television's greatest hits. Collecting is also a timely issue because artists and critics are now asking new questions about the role of the museum and the artist in creating culture and defining value through the formation of collections. This exhibition raises many provocative questions that are pertinent to institutions and individuals alike. To connect the exhibition even further to the presenting institution's community, each venue has been encouraged to add a collection of their own choosing—the "More" in the exhibition's title.

The encouragement, dedication, and generosity of many people have enabled ICI to produce this traveling exhibition and catalogue. First and foremost, I extend our warmest thanks to guest curator Ingrid Schaffner. Our invitation to Ms. Schaffner to develop this project began with ICI's wish to collaborate with The Robert J. Shiffler Foundation—an organization whose mission and educational focus are not unlike ICI's. To this mandate Ms. Schaffner brought her substantial art historical knowledge, critical and curatorial skills, and imagination, creating an exhibition that presents an outstanding selection of contemporary art and investigates a wide range of ideas about collecting.

In order to expand our understanding of the works in this exhibition and the various issues surrounding the subject of collecting, this catalogue includes essays by three authors to whom I want to express our gratitude. Ms. Schaffner introduces the curatorial concept and its significance, and discusses the works in the exhibition; Dr. Werner Muensterberger reveals the psychological dimension of collecting; and Fred Wilson contributes his views as an artist whose projects have often used museum collections to investigate political, social, and cultural issues.

Pictures, Patents, Monkeys and More…On Collecting would not have been possible without the involvement of the three lenders to this exhibition, to whom I would like to express our most sincere thanks. Robert Shiffler's collection, built with enormous understanding of and appreciation for artists' contributions to our society, was an inspiration for this exhibition—as was his Foundation, which he established to make his collection and archive available to the public. His dedication to sharing the works he has acquired has been key to making this exhibition possible. The Foundation's knowledgeable archivist, Peter Huttinger, has generously assisted ICI from the start of this project, with skill, enthusiasm, and patience.

The patent models in this exhibition are today in the collection of the National Museum of American History, Smithsonian Institution, and are distributed (according to the purpose of each invention) among more than a dozen museum departments. We are indebted to the many

curators and other professionals in these departments for their assistance. In our research, we were guided by Barbara Suit Janssen and her book *Icons of Invention: American Patent Models*. For their assistance with loan requests, help in selecting the most meaningful patent models, and lessons in the fascinating history of patents in the United States, we would like to thank Margaret Grandine, outgoing loans manager; and Pete Daniel, Larry Jones, Susan Tolbert, Roger White and William Worthington, specialists, Division of the History of Technology; Barney Finn, curator, Electrical Collections; Michelle Delaney, specialist, Division of Information Technology and Society, Ms. Janssen, curator, Division of Textiles; Peggy Kidwell, curator, Mathematics Collection; Anne Serio, specialist, Division of Social History; David Shayt, curator, Division of Cultural History; Diane Wendt, museum specialist, Division of Pharmacy and Public Health; and Bill Withuhn, curator, Division of the History of Technology.

Finally, I want to express our warmest thanks to the private collector of sock monkeys. We are grateful for his willingness to entrust us with one hundred of his carefully and lovingly acquired possessions. This handcrafted toy, whose golden age was the 1950s, can now be shared with museum audiences across the United States.

The educational materials developed to accompany this exhibition were created with the expert assistance of education consultant Joan Horn, and enriched by the generous contribution of sock monkey kits from Fox River Mills, Inc. Thanks are also extended to Leah Buechley, who assisted Ms. Schaffner on this project.

We were fortunate to work on this catalogue with several excellent collaborators: graphic designers Barbara Glauber and Beverly Joel of Heavy Meta who translated the project's concept into their graphic design; editor Lisa Cohen, whose careful attention to all the texts was essential; and Arne Svenson whose photographs convey vividly the special qualities of the sock monkeys.

ICI's dedicated and knowledgeable staff deserves thanks for their work on every aspect of this project. In particular, Carin Kuoni, director of exhibitions, helped to form the exhibition with the curator and, working with Jack Coyle, registrar, and Jane Simon, exhibitions assistant, carried out all of the tasks needed to develop this catalogue and form a unique exhibition from three very different groups of works. Other members of ICI's staff who contributed to this project in important ways are Hedy Roma, director of development; Colleen Egan, development associate; Sarah Andress, exhibitions assistant; Sue Scott, executive assistant; and Dolf Jablonski, bookkeeper.

Finally, I extend my warmest appreciation to ICI's Board of Trustees for their continuing support, enthusiasm, and commitment to all of ICI's activities. They join me in expressing our gratitude to everyone who has contributed to making this project possible.

—Judith Olch Richards, Executive Director

THE ROBERT J. SHIFFLER
FOUNDATION

Ohio businessman Robert J. Shiffler has been collecting artworks since 1986. In 1998, he established The Robert J. Shiffler Foundation to promote avant-garde culture in its most challenging manifestations, through tours of the collection, special events, a Web site, educational programs, exhibitions in its Greenville, Ohio, storefront, and an unusually generous loan policy. The art collection now totals over six hundred works, with a companion collection consisting of an important archive of artists' books, multiples, performance documents, videos, computer-based works, and audio recordings.

Owning anything is a responsibility, but Shiffler's collection—and its public mission, which he considers a priority—comes with particular burdens. In addition to spoilage (more than a few works involve organic materials), there are issues of storage (the foundation rents a former department store in Downtown Greenville, which can be visited by appointment), administration (a curator/archivist is in charge of the collection), preparation (art handlers are called in to help with loans and installations), insurance, and maintenance. Shiffler admits that his resources are not unlimited: he tends to buy works by artists whose careers are just about to take off—in other words before their prices soar out of his reach. But with his unusual level of commitment comes the opportunity to contribute to and observe contemporary culture at the very level of its making. —I.S.

Artworks in storage at the
Robert J. Shiffler Foundation,
Greenville, Ohio

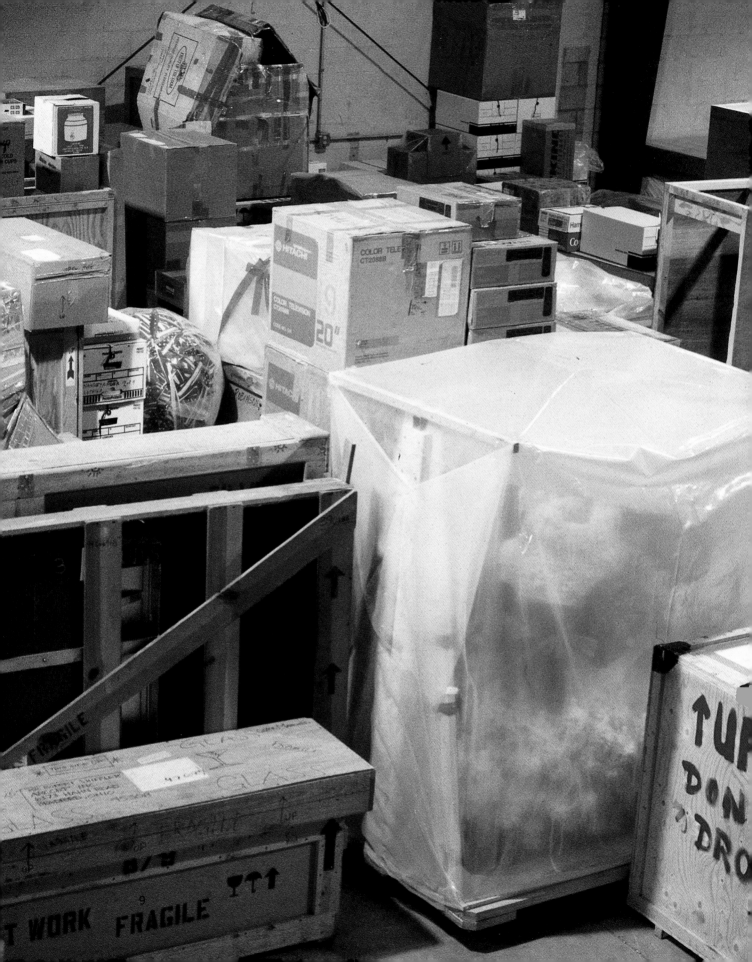

The following works from the archive are presented in the exhibition:

LAURIE ANDERSON
It's Not the Bullet that Kills You It's the Hole, 1977
7 inch 45 rpm record in white paper sleeve

RON ATHEY
Suicide Box, from 4 Scenes in a Harsh Life, 1993–95
Performance relic
Wooden box, syringes, tie-off, mirror fragment with blood drops, spinal needles, and a surgical scalpel
9 1/4 x 3 1/2 x 6 inches (closed)

BETH B
Amnesia, 1992
Video, color/sound
1:00 minute

CHERYL DONEGAN
Head, 1993
Video, color/sound
6:00 minutes

BOB FLANAGAN AND SHEREE ROSE
Death Monologue, 1994
Video, color/sound
13:00 minutes
Performance documentation. The Death Monologue was performed at LACE, Los Angeles, California, on February 15, 1994.

SYLVIE FLEURY
Vital Perfection (Shoe Box), 1993
Cardboard and fake fur
Signed edition of 100, artist's proof
6 1/2 x 11 x 4 inches

GENERAL IDEA
Ouroborous (Green Poodle with Long Tail), 1988
Chenille crest
Open edition
9 1/2 x 8 1/2 inches

GILBERT & GEORGE
Fan, 1988
Offset printed paper, mounted on wood, with color illustration
9 x 16 1/4 inches

JOHN GIORNO
Life is a Killer from **You've Got to Burn to Shine**, 1992
Offset printed book, text: English and German, perfect bound in slipcase, with audio cassette tape
Signed and numbered edition of 500
Stop Over Press, New York
6 1/4 x 4 1/2 x 1 1/2 inches
3:05 minutes

JACK GOLDSTEIN
The Murder, 1977
12 inch, 33 rpm black vinyl record in white plain paper jacket
Self-published, New York

GREGORY GREEN
Intruder, Kilroy, Stealth, and Timid Viruses, 1994
Four 3 1/2 inch floppy diskettes (with computer viruses) in a plastic box
Signed and numbered edition of 25
4 1/4 x 4 1/4 x 1/2 inches

HANS HAACKE
Silver Glance (Silberblick), 1990
Offset printed shadow box with die-cutting, plastic and German coins (1 Deutsche Mark and 2 DDR Marks [German Democratic Republic])
Numbered edition of 90
9 x 6 1/2 x 1/2 inches

LAURA HERMAN DISTEL
Above and Below, 1997
Video, b&w/sound, 2:50 minutes
Written and directed by L. A. Herman; starring Andrea Sparks and Steve Billips; narrated by Erin Homan

AMY K. JENKINS
Closures, 1996
Video, color/sound
2:30 minutes

MARTIN KIPPENBERGER
Broken Centimeter, 1991
Bronze disk (diameter: 2 inches x 1/4 inches) in printed suede pouch (3 3/4 x 2 1/2 inches)
Stamped and numbered edition of 1,000,000

CARY LEIBOWITZ
Class Sissy Football, 1991
Pink and blue rubber football with imprinted text: "Official Candyass Class 'Sissy' Football"
5 x 9 x 5 inches
Edition of 500 (1s printing)

SHERRIE LEVINE
Shoes, 1977
Leather and fabric
Each shoe: 6 1/2 x 2 1/2 x 2 1/2 inches
Performance relic from Shoe Sale, performed at the Mercer Street Store, New York, New York

LIBERTY AMATEUR STUNT ALL STARS
Liberty Amateur Stunt All Stars, 2000
Offset printed match books
2 x 1 1/2 inches

Liberty Amateur Stunt All Stars, 2000
Video, color/sound
2:53 minutes

JOHNNA MACARTHUR
Ants, 1996
Video, color/sound
5:00 minutes

CHRISTIAN MARCLAY
Jimi Hendrix, from **More Encores**
10 inch, 33 rpm record in color illustrated jacket
2:54 minutes

MATT MARELLO
Sitcoms: The Beverly Hillbillies with Special Guest Star Jean Paul Sartre, 1996
Video, color/sound
4:00 minutes
From Sitcoms (Anthology), 1996.

LARRY MILLER
Orifice Flux Plugs, 1972
Plastic box, paper label, and found objects
8 3/4 x 13 x 3 inches
Open edition

ALIX PEARLSTEIN
Flower, Flower, Flower..., 1995
Video, color/sound
15:00 minutes

RICHARD PRINCE
Untitled (Hat), n.d.
Black wool hat embroidered, in silver thread, with an image of skull with Playboy Bunny ears
5 x 8 1/2 x 7 inches

DIETER ROTH
Collected Works, vol. 15; Poetry 5 to 1 (Gesammelte Werke, Band 15; Poetrie 5 bis 1), 1969
Special edition bound in painted (blue) rubber cover with 2 two-color Polaroid photographs mounted into front and back covers, offset printed book, paper
9 1/4 x 7 x 1 1/4 inches, 220 pages
Signed and numbered edition of 100 (1st printing)

MICHAEL SNOW
Left Right from **Musics for Piano, Whistling, Microphone, and Tape Recorder**, 1975
12 inch, 2 discs, 33 rpm
22:43 minutes
Illustrated jacket, black-and-white illustrations, audio composition, cover and text by Snow
Chatan Square Records

LAWRENCE WEINER
Afloat, 1992
Ballpoint pen, with text floating in water-filled chamber, packaged in an offset printed, signed, and numbered box
Pen: 6 inches
Edition of 500

WO SHAN ZHUAN
Missing Bamboo, 1993
Plush mechanical toy panda in box
Box: 6 x 9 3/4 x 5 inches, with label, postcard, color illustration, and rubber stamp (signed)
Toy: 5 3/4 x 5 x 9 inches
Multiple/Exhibition ephemera.

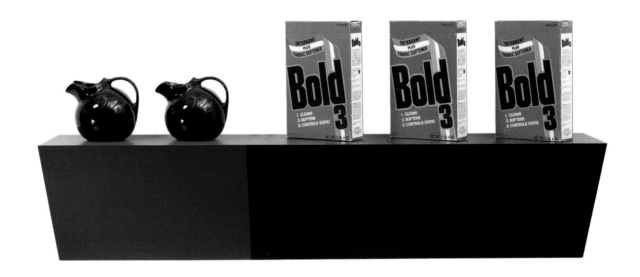

HAIM STEINBACH
Supremely Black, 1985
Mixed media on Formica shelf
29 x 66 x 13 inches

11

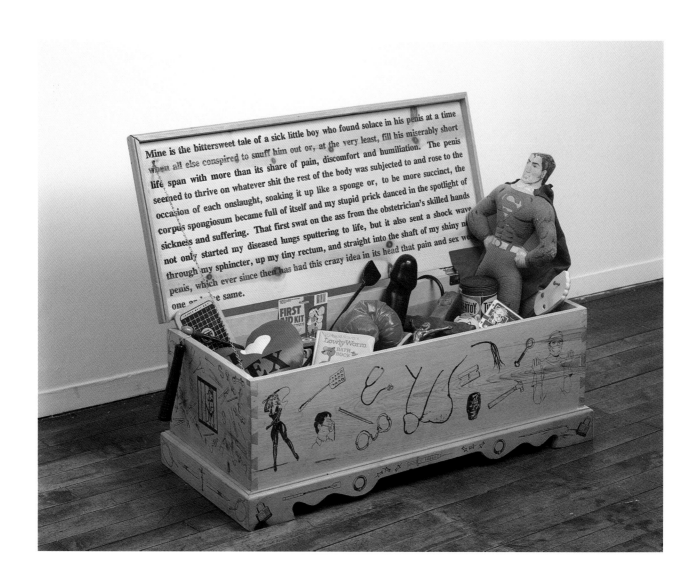

Mine is the bittersweet tale of a sick little boy who found solace in his penis at a time when all else conspired to snuff him out or, at the very least, fill his miserably short life span with more than its share of pain, discomfort and humiliation. The penis seemed to thrive on whatever shit the rest of the body was subjected to and rose to the occasion of each onslaught, soaking it up like a sponge or, to be more succinct, the corpus spongiosum became full of itself and my stupid prick danced in the spotlight of sickness and suffering. That first swat on the ass from the obstetrician's skilled hands not only started my diseased lungs sputtering to life, but it also sent a shock wave through my sphincter, up my tiny rectum, and straight into the shaft of my shiny new penis, which ever since then has had this crazy idea in its head that pain and sex were one and the same.

BOB FLANAGAN AND SHEREE ROSE
Toy Box, 1992
Wood box and mixed media
42 x 15 x 20 inches
Courtesy the Estate of
Bob Flanagan

12

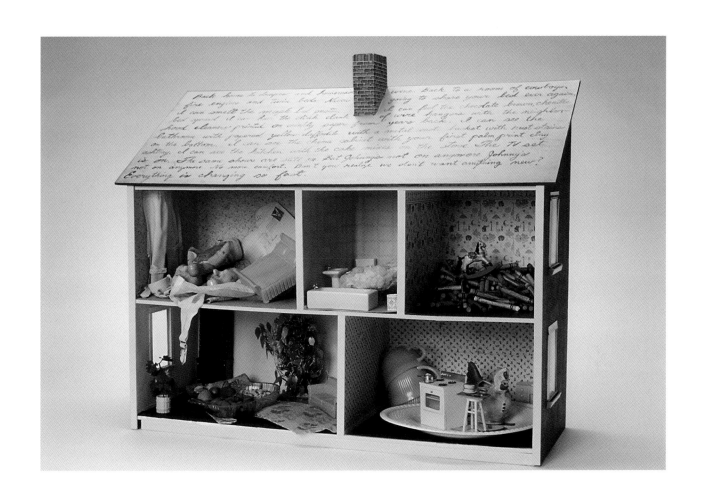

KAREN FINLEY
Dollhouse: Back Home, 1994
Mixed media
26 3/4 x 31 x 11 3/4 inches

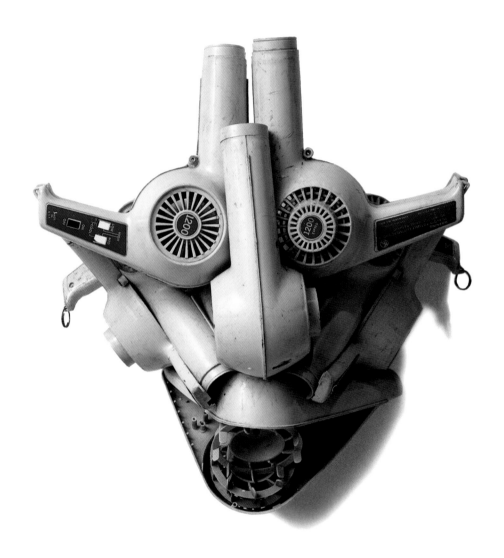

WILLIE COLE
Wind Mask, 1991
Hair-dryers
21 x 20 x 10 inches

14

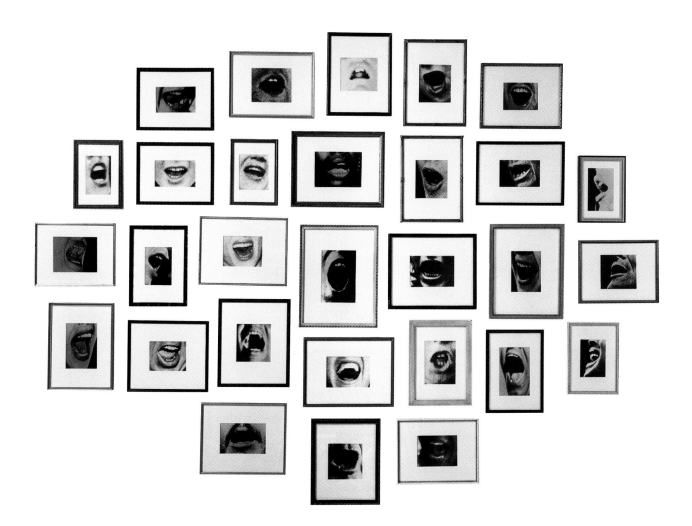

CHRISTIAN MARCLAY
Chorus, 1988
Twenty-nine framed, black-
and-white photographs
56 x 74 inches

15

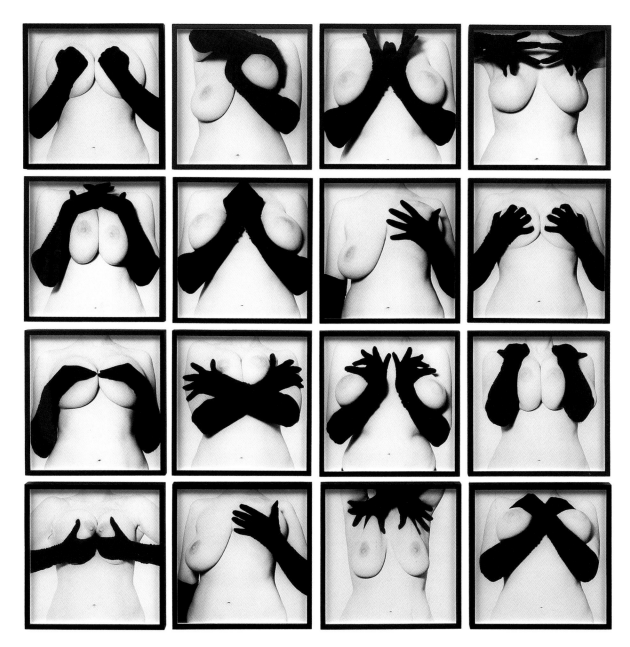

ANNIE SPRINKLE
Bosom Ballet, 1986/98
Sixteen silver gelatin prints
Performance photographic
series based on Bosom Ballet;
photographed by Mark Trunz.
Signed edition of ten
70 x 70 inches (overall)

16

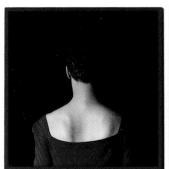

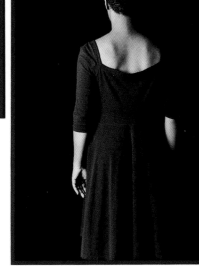

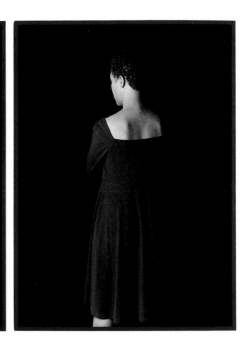

1 in a hundred
1 out of 3
2 out of 7
3 out of 4
one fifth
1 in ten
99 ⁹⁹⁄₁₀₀%
75%
10%
20%

LORNA SIMPSON
Odds, 1991
Three black-and-white
gelatin silver prints with ten
plastic plaques
55 x 114 inches (overall)

17

cyciphuss

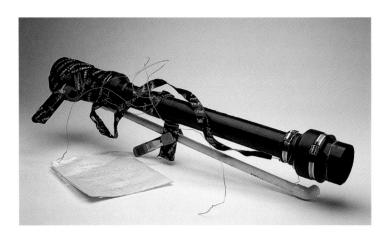

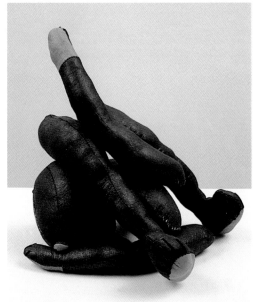

KAY ROSEN
Sisyphus, 1991
Video (video still)
Unlimited edition
7:30 minutes

JASON RHOADES
A.B.S. Gun with Pom Fritz
Choke and Aqua Net, 1994
PVC pipe, wire, tape,
wood, and operating manual
37 x 9 x 8 inches

CHARLES LEDRAY
Untitled (Bear), 1992
Fabric, thread, cotton batting,
and buttons
9 1/2 x 8 x 8 1/2 inches

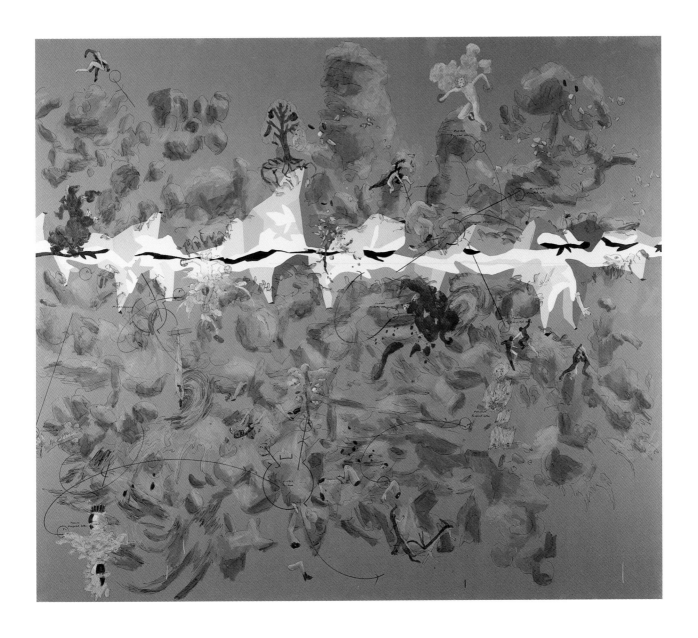

MATTHEW RITCHIE
The Binding Problem, 1996
Oil and marker on canvas
86 x 100 inches

THE SIGNIFYING MONKEY

The Monkey and the Lion
Got to talking one day.
Monkey looked down and said, Lion,
I hear you's king in every way.
But I know somebody
who do not think that is true-
He told me he could whip
the living daylights out of you.
Lion said, Who?
Monkey said, Lion,
He talked about your mama
And talked about your grandma, too,
And I'm too polite to tell you
What he said about you.....

CARRIE MAE WEEMS
Untitled (Signifying Monkey) from the "Sea Island Series," 1992
Text panel
Edition 1/10
39 x 29 1/2 inches

PAUL RAMIREZ-JONAS
Hexagonal Box Kite after Alexander G. Bell, 1993
Cotton fabric, wood, camera, alarm clock, string, small metal parts, and C-print photograph
42 x 48 x 70 inches (kite)
30 x 20 inches (photograph)

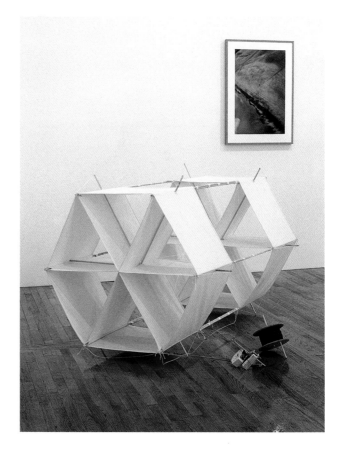

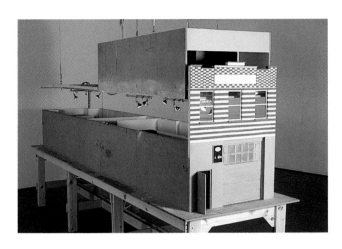

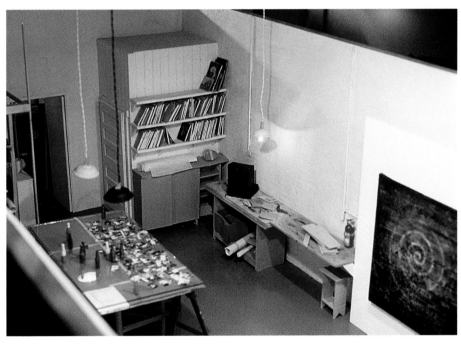

FOUR WALLS
Artists include Judith Barry,
Jessica Diamond, Cary
Leibowitz/Candyass, Marlene
McCarthy, Cady Noland, Kay
Rosen, Susan Silas, Lawrence
Weiner, and Sue Williams.
Concept by Michael Ballou.
Small Talk, 1992
Mixed media
Miniature replica of the artists'
collective gallery space in
Brooklyn, New York, featuring
the exhibition *Small Talk*
curated by Marilyn Minter.
84 x 168 x 48 inches

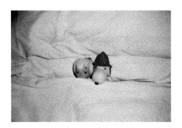

FELIX GONZALEZ-TORRES
Untitled, 1994
Color photograph in plastic
frame
From PORTRAITS, Printed Matter
Portfolio (vol. 1), published
by Printed Matter, New York
Edition 3/25
4 x 6 x 1 inches

RIRKRIT TIRAVANIJA
**Untitled (Apron and Thai
Pork Sausage)**, 1993
Hot pressed decal on brown
paper with recipe
Edition of 25
Published by Brian Multiples,
Santa Monica, CA
47 x 28 inches

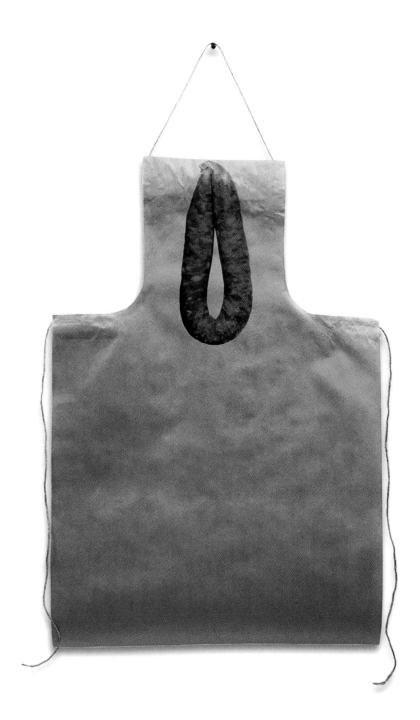

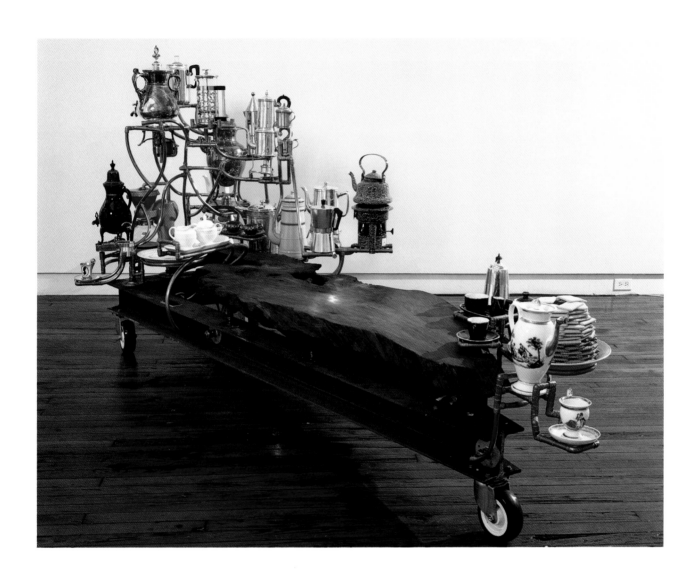

JOEL OTTERSON
Coffeetable Museum, 1989
Redwood burl, various
antique and contemporary
coffeepots, copper plumbing
pipe, brass fittings,
welded steel, wheels, and
mixed media.
55 x 126 x 51 inches

23

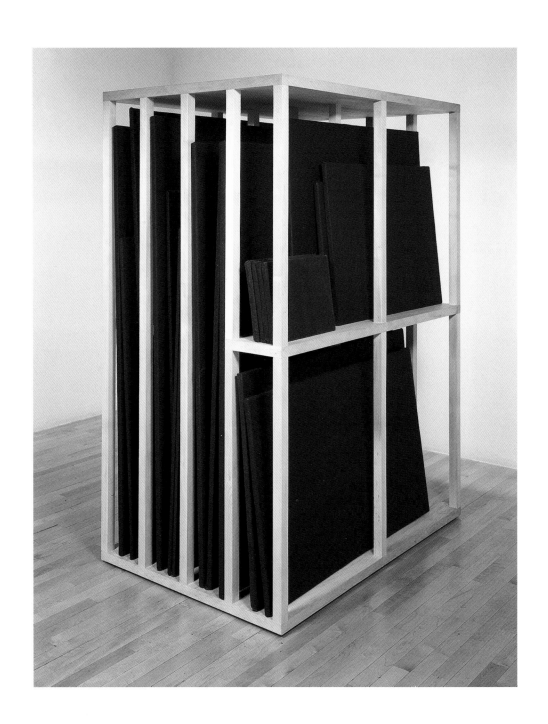

TONY TASSET
Collector, 1989
Wood and felt
72 x 36 x 54 inches

BRIAN TOLLE

**Declaration of Independence
Desk: Bismarck**, 1995
Wood, felt, and metal
hardware
9 3/4 x 14 1/2 x 3 1/4 inches

**Declaration of Independence
Desk: Brian Tolle**, 1994
Corrugated cardboard with
paper label
Edition 2/20
9 3/4 x 14 1/2 x 3 1/4 inches

**Declaration of Independence
Desk: Robert J. Shiffler/
Levenger**, 1995–96
Wood, felt, and metal
hardware; desk purchased
(mail-ordered) from the
Levenger Company
9 3/4 x 4 1/2 x 3 1/4 inches

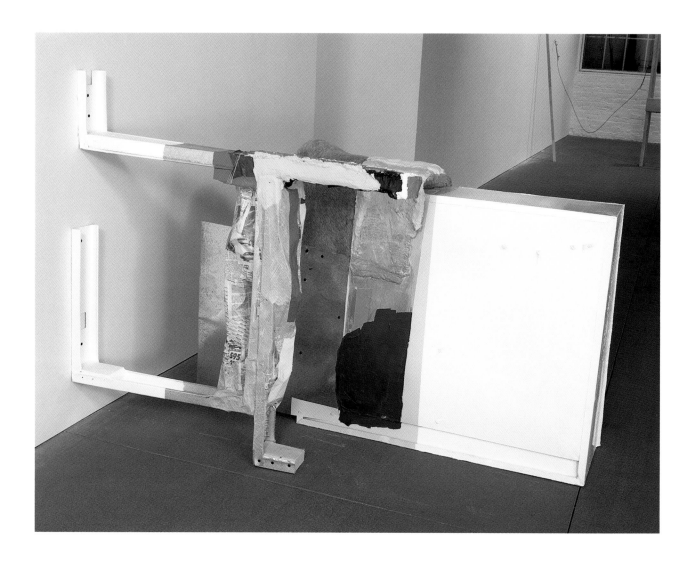

JESSICA STOCKHOLDER
1990, 1990
Fake bricks, metal studs, metal
cabinet, newspaper, glue,
cloth, wire, roofing tar,
string, sheet metal, wood,
oil paint, and acrylic paint
61 x 20 x 34 inches

26

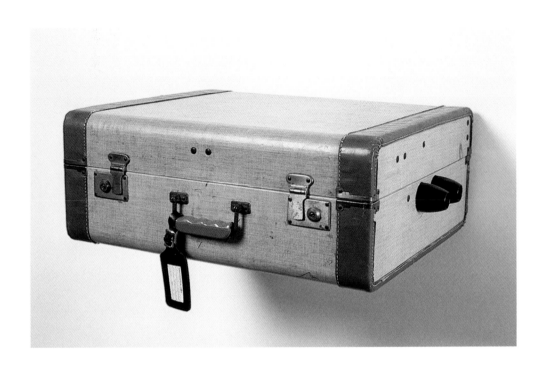

PERRY HOBERMAN
Sex, 1992
Suitcase, fluorescent light,
and transparencies
9 x 25 x 20 inches

GREGORY GREEN
Pipe Bomb # 5 (New York), 1992
Egg timer, batteries,
electrical wire, duct tape,
and pipe
13 1/2 x 4 1/4 x 4 1/4 inches

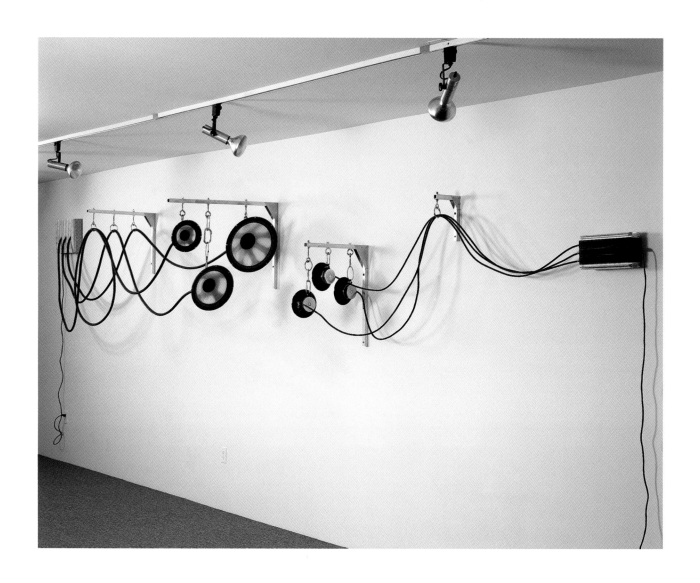

ALAN RATH
Off the Wall IV, 1993
Electronics, aluminum, and
speakers
86 x 260 x 36 inches

SUE WILLIAMS
Orange and Blue Sentinel
Frocks, 1998
Oil and acrylic on canvas
82 x 132 inches

LISA YUSKAVAGE
Fleshpot, 1995
Oil in canvas
68 x 50 inches

JANINE ANTONI
Undercover, 1991
Coat and lipstick in cases
(performance relic)
40 x 24 x 4 inches

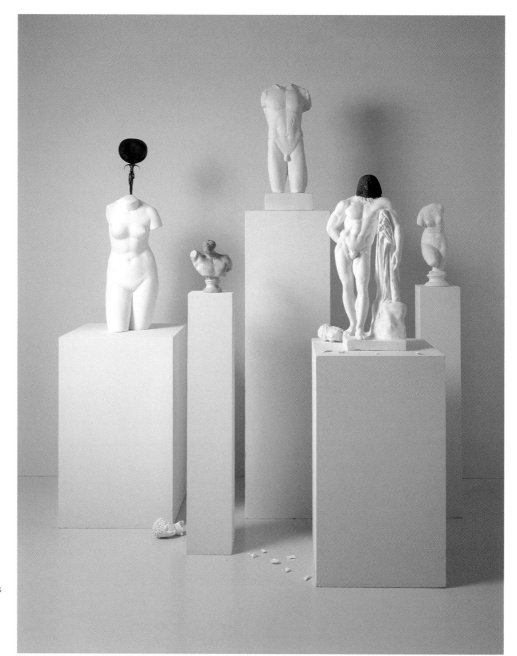

FRED WILSON
Panta Rei. A Gallery of Ancient Classical Art, 1992
An installation of five sculptures [left to right]:

Two Goddesses, 1992
Plaster, pedestal, and mixed media
75 x 21 x 21 inches

Untitled, 1992
Plaster cast on pedestal
54 1/2 x 22 1/2 x 22 1/2 inches

Osiris, 1992
Plaster on pedestal
88 x 17 x 17 inches

Untitled (Hercules), 1992
Plaster cast on pedestal
51 1/2 x 22 1/2 x 22 1/2 inches

Cleopatra, 1992
Plaster cast on pedestal
61 1/2 x 8 x 8 inches

INGRID SCHAFFNER

On collecting

Why didn't she try collecting something?—it didn't matter what. She would find it gave an interest to life, and there was no end to the little curiosities one could easily pick up.

—HENRY JAMES, *The Spoils of Poynton*

I have been accumulating writings on collecting, and the reading is telling. One minute you might be reading about butterflies, for example, or about a person who devotes untold hours of his or her life to getting more butterflies—the next minute you find yourself grappling with questions about history, economy, destiny, science, naming, language, learning, love, immortality. Even the most ephemeral, least significant writings on collecting somehow induce a bewildering amount of speculation.

Sample the two modern classics. Walter Benjamin's 1931 essay *Unpacking My Library* opens with a charge of the perverse pleasure this Marxist philosopher gets in seeing his private collection of old books emerge from packing crates.[1] Disheveled/dis-shelved, the unpacked books not only convey but arouse the collector's passion. At his touch—almost a fondle—each volume relinquishes a "chaos of memories."[2] He contrasts to this productive chaos the "mild boredom" of seeing any collection neatly arranged—its disorderly essence (a historic essence) subdued, made static, like facts in a chronology.[3] The pleasure his collection unleashes has little to do with its contents: the last thing a collector does is read his books![4] No, the relationship between collector and object is based on memories of a first encounter, a city, a dealer, a transaction, a touch. The essay concludes with Benjamin's abrupt, yet wistful, prediction that private collecting would someday constitute an obsolete form of ownership.

Bruce Chatwin's short fiction *Utz* picks up where Benjamin leaves off, investigating the mysterious fate of Baron Utz's vast collection of Meissen porcelain figurines, in postwar Prague. Utz has struck a deal with the Socialist government, allowing him to keep his acquisitions until his death. He warns: "In any museum the object dies—of suffocation and the public gaze.... Ideally, museums should be looted every fifty years, and their collections returned into circulation."[5] And at the old man's funeral, the entire collection has vanished, without a trace. Perhaps, the narrator speculates, Utz destroyed his aristocratic Harlequins, Columbines, and monkey musicians rather than have them possessed by the State. Or is it possible that after marrying his devoted maid, Marta, Utz no longer relied on the chilly comfort of Rococo porcelain objects, and the aged couple together smashed the lot?

Turning to more varied sources, one discovers recurrent motives and points of consensus as well as some knotty contradictions. Compulsion, a word that smacks of perversion and illness, commonly describes the collecting impulse (which is also sometimes called a "mania"). As Chicago art collector Frederic Clay Bartlett testified, "I am a collector. It is a habit—a disease with me. I cannot help buying curios, antiquities, and works of art, even when I have no place to put them."[6] And yet, this impulse has also been regarded as normal, as something to be cultivated from childhood on. "The tot of two," a parenting article from 1919 assures us, "when he starts to collect, has entered the first business enterprise of his life."[7] Sigmund Freud was deeply inspired by the act of collecting and by the objects in his own collection of some 2,000 (mostly small) antiquities. When the Nazis occupied Vienna, Freud refused to leave until safe passage to London was assured both his family and his collection. And psychoanalytic practice was built on the idea of retrieving things (material) from an individual's collection of images, thoughts, memories, fragments, dreams, and fears—all of which Freud called the unconscious.[8]

Hunting is the great metaphor of collecting, with tracking, the chase, the bluff, capture, the elements of risk and chance all presumed to be more thrilling than the quarry itself. Collectors are frequently likened to "lions," and in one case to "ferrets": "The collecting of one type...is bold and voracious; the collecting of men of the type of Balzac's 'Cousin Pons' is artful, cunning, crafty."[9] Embedded in the hunting/trophy metaphor is a tradition of collecting as plundering, or acquisition through conquest—to the victor go the spoils. In 67 B.C., for example, Roman emperor Cicero begged his contact in Greece to please send "as many other statues and objects as seem to you appropriate to that place, and to my interests, and to your good taste—above all anything which seems to you suitable for a gymnasium or a running track."[10] In a strange twist to this adage, Napoleon, though defeated in battle, sacked Egypt of its treasures and carried them off to France in triumph—a triumph of collecting, that is.

Love, learning, identity, immortality, and investment are the big motives for collecting.

As one commentator observes of the tender ministrations that collectors lavish on their objects: "while love for another person may be spurned, no one was ever jilted by a book mark or a cheese label."[11] Alternatively, however, collecting can lead to friendships and build community. Surely the members of MOO: Milk Bottles Only Association find exceptional company in their own midst. Built over time, a collection is a life's witness. The writer Kenneth Breecher has observed: "There were postcards from every period of my life and they had become my private museum, a cabinet of curiosities, a personal history reflecting large and minute concerns."[12] Every collector learns from his or her pursuit, and collections can also teach others. The seventeenth-century genesis of the museum—the curiosity cabinet, or Wunderkammer—was composed equally of natural specimens and cultural artifacts for study and teaching purposes. Joseph Pulitzer said that building his art collection goaded him to constantly rethink his own knowledge and taste: "If I have been troubled or dismayed or shocked or antagonized by a style that suddenly emerges on the scene, I usually take the trouble to find out about it."[13] But collecting is not first and foremost about communicating with others, and collectors' expertise can veer to the sheer arcane and be couched in a language sensible only to other collectors, with their knowledge of rare patterns, maker's marks, years of manufacture, most desirable colors, and other minutiae. This is the parlance of the marketplace and is not usually relevant to discussions of culture or history at large.

Collections establish and reveal identity. Mega-collector and twin Alex Shear has noted that he "didn't know who [he] was," until the day he found himself at a flea market, reconstructing the consumer landscape of his past (from bobby pins, to soda cans, to artists' renderings of never-built cars) and started acquiring these products of his youth en masse. "Is my collection autobiographical?," he asks; "you'd better believe it. A lot of my life is in that stuff."[14] But collections don't just reflect on a collector's past, they also look forward to the time of his or her death. On donating his collection of Victorian art to Canada's National Gallery, Joseph Tannenbaum declared: "There's something almost immortal about collecting. It's a heritage you pass on to future generations."[15] Even when a collection isn't fit to enter an institution's pearly gates, there is a sense of its heft and responsibility anchoring the collector to this world. As a collector friend once said to me, "I can't die; who will take care of all these things?"

But collecting is also about investing in the here and now: "Most of us, of course, collect for profit, whether real or imagined."[16] And, increasingly, *everything* seems collectible, and thus valuable. Each episode of the popular television program *Antiques Road Show* stars ordinary household accumulation that an expert's word either transforms into a pearl of great price or reduces to trash. With e-bay and on-line auctions taking place virtually every second of the day, collectors are constantly buying and selling, incrementally and exponentially

inflating their own economies in Russell Wright-designed dishes, Impressionist paintings, tractor brochures, and so on. Nonetheless, collecting is ultimately about accumulating, not about cashing-in. For what do true collectors do with any financial gains? They buy more stuff.

Finally, the Golden Rule, encountered again and again throughout the writing on collecting, is that *everyone collects something*. On a certain level, collecting is naming (you name it and someone collects it...); it is a kind of pointing to the object. And collectors in turn are named: a deltiologist collects postcards, a phillumenist matchbook covers, a vitolphillist cigar rings.[17] Snobs might quibble over the difference between dilettante and genuine collecting. "The latter," one commentator observes, "has stilled once and for all any inhibition against spending money on the inanimate objects of his choice."[18] But money isn't really the issue when you collect, as some do, rubber bands, restaurant doggie bags, string, or other ephemera. We live in a culture so possessed by possessions that a person would almost have to make an effort *not* to collect. Emerson's warning, "Things are in the saddle and ride mankind," receives this update from the editor of *The Antique Trader Weekly*: "grab as much as you can and store it."[19]

An essential question remains, even after having sifted through my collection of writings on collecting: How and why do people chose what they want to collect? What is it about asphyxiated butterflies that can drive one person to distraction, while others daydream about small antiquities? How thrilling is the pursuit of miniature lamps if one is not already captivated by them? A fine collection of cheese labels may keep emotional entanglements with human beings at bay, but love is there nevertheless. Ultimately, I cannot explain the pleasure that I get from my own modest collection of old travel books—with their exquisite maps, handsome heft, delicate paper, stone-by-stone accounts, and obsolete accommodations—and I do not expect anyone else to fully appreciate or share it. (In fact, I hope you don't. Like most collectors, I'm a little proprietary when it comes to my object.) This aspect of collecting—the hold certain objects can have on us—seems to lie beyond speculation. The desires and assurances they inspire remain ineffable.

Pictures, Patents, Monkeys, and More

The three (and more) collections that are the subject of this exhibition are each represented by selected objects and each depict a different kind of collecting: contemporary fine art comes from the Robert J. Shiffler Foundation in Ohio; the sock monkey toys, artifacts of popular culture, come from a private collection; the patent models, an example of a repository of public record, are from the U.S. Patent Office, and are now in the collection of the Smithsonian Institution. In addition, each participating venue has been invited to present a local collection.

Seeing all of these objects side-by-side gives rise to a variety of questions and

comparisons. For example, how are institutional and individual collecting different from one another? Art is generally considered the "big game" of collecting, because of the relatively high cost associated with obtaining and maintaining individual objects, and because of the status they confer. Yet, as expressions of innovation and individuality, are pictures actually unlike patents or sock monkeys? What about the power and significance of the collection itself? How does the fact that an object has been collected transform the regard we have for it? Is there a point when an accumulation becomes a collection? And can a collection itself become a work of art? We also have to pay attention to the context of display: art museums create a privileged form of presentation, which reflects on all the objects on view here. If Marcel Duchamp could, in 1915, turn a shovel into a sculpture just by showing it as such, what does that gesture mean for these monkeys and patents? By extension, is fine art leveled by such associations? I think not: art maintains its cultural position and its specific claims on our attention, though not at the expense of any of the other objects on view here. What attracts you personally is of course a matter of taste. But everything in this show, including the art, gains from the *frisson*, the excitement the exhibition generates simply by showing it together and making it possible to ask these questions in such a direct and open-ended manner.

Mr. Shiffler's most active period of acquisitions was the early 1990s: a time when there was a proliferation of works dealing with themes of gender, racial, and sexual identities. Karen Finley, one of the artists singled out at the start of the national debate about censorship in the arts, is represented here by *Dollhouse: Back Home*, 1984 (page 13).[20] The lines of text scrawled on the roof of the house come from a performance piece of Finley's that begins, "Back home to drapes and homemade wine. Back to a room of cowboys, fire engines and twin beds. Never going to share your bed again." Crammed with miniature and full-scale objects, the tiny rooms are full of the sense of violence that storms through Finley's work, as it protests against incest, homophobia, and the degradation of women. Lorna Simpson's *Odds*, 1991 (page 17), uses photos of the artist seen from the back and text panels that give statistics about minority (20%) and majority status ("3 out of 4"). Here the artist portrays herself as an objectified "other," and raises issues about African-American identity.

Today, new practices are evolving as art moves outside studio and gallery conventions. Gregory Green is one of a number of artists to use the computer as medium. On a rather destructive note, his *Intruder, Kilroy, Stealth, and Timid Viruses*, 1994, is a floppy disk loaded with programs to destroy a computer's memory. Using readily available information and technology, Green's art talks about access to power. Look carefully for his *Pipe Bomb #5 (New York)*, 1992 (page 27), a tool of the terrorists trade, installed discretely in the gallery, out of sight.[21] A collaborative work by Four Walls, a gallery in Brooklyn run by artists (as opposed to

art dealers) for artists, speaks to the kinds of changes that have taken place inside art's systems of power. The piece *Small Talk*, 1992 (page 21), is an exact replica of the gallery space; it is filled with miniature artworks created especially for this miniature exhibition (one of six that took place within its miniature walls). Based on a concept by Mike Ballou, this particular exhibition was curated by artist Marilyn Minter.

Contemporary art based on or interrogating images and strategies of collecting is of particular interest to *Pictures, Patents, Monkeys, and More*. A kitsch celebration of highbrow cultural ambition, Joel Otterson's *Coffeetable Museum*, 1989 (page 23), displays a fine array of coffee services, the probable provenance of which were thrift stores and yard sales. The base of the museum is a superb piece of hippie Rococo: a burl table, ornamented in a fretwork of copper plumbing. The identity of Tony Tasset's *Collector*, 1989 (page 24), appears anonymous, as do the acquisitions representing him or her: sleek canvases slotted into a storage rack. The work's darkness gives it a funereal aspect that echoes Baron Utz's prognosis: collections can prove deadly to the objects collected. Fred Wilson refreshes this moribund image by taking a collection of headless Classical figures and topping some of them off with heads from Ancient Egyptian sculptures. This simple gesture shifts art's origins from an ostensibly "pure" white Mediterranean culture to one interwoven with Black African culture.[22]

The selection of works from the Foundation's collection (and archive) also reflects Mr. Shiffler's unique vision and taste, or, as he puts it, his "personal sense of what 'feels' right about an object or an image."[23] This taste, paradoxically enough, tends towards the un-collectible. Shiffler is undaunted by organic materials, elaborate installations, new technologies, or challenging (especially sexually explicit) content. A huge amount of space at the Shiffler Foundation has been given over to accommodating Rirkrit Tiravanija's *Untitled (Free/Still)*: a rambling kitchen complex, complete with occasionally exploding leftovers from a curry supper the artist prepared for a gallery show in 1993.[24] Shiffler collects the work of Annie Sprinkle, whose *Bosom Ballet*, 1986/98 (page 16), is an unusually formal—but typically bawdy and funny—example of this performance artist/porn star's art. He also helps maintain the estate of Bob Flanagan, who until his death from cystic fibrosis in 1996 used his sadomasochist art to live up to his motto: "fight sickness with sickness."

In an exhibition devoted to collecting, this commitment to the un-collectible calls for further scrutiny. If collecting art is about status and identity, what exactly is being conferred here? Acceptance, apparently. Shiffler confides: "I enjoy acquiring work that people find peculiar and hard to deal with. I suppose this stems from the 'in your face' part of my personality that has been deliberately and painfully repressed in order to allow for my more comfortable (and

perhaps safer) existence in society." But it's not only his identity that is at stake. One publication of Shiffler's collection contains a dedication to his brother Richard, "whose lifetime struggle for acceptance has been set aside during his fight against AIDS." This dedication informs Shiffler's entire collecting practice. It suggests why he selects the art he does: when not directly about AIDS, it is still often about abject and desiring bodies, and about arousing anger, representing difference, showing leaps of faith, or simply challenging our complacency. This quality, in turn, suggests why Shiffler collects art and not, say, sock monkeys or patents. Art enables him, as it does all viewers, to engage life—its pleasures, pains, and paradoxes—both through and beyond individual experience. Art is a form of open-ended communication that exists as both the subject and object of interpretation—which explains why Shiffler has put so much energy into making his collection seen. He says: "I am driven by a genuine belief that people's lives are enriched when their minds are opened to new ideas or directions. I view the sharing of the collection and its archive...as a natural obligation of the collector."

Collecting goes in waves—each bringing new streams of contacts—as the anonymous owner of the sock monkey collection has observed. A popular form of handcraft since the 1950s, a sock monkey is a stuffed toy made from a pair of cotton socks. When the collector first began searching for them in 1985, he quickly amassed them through purchases at flea markets and antique stores, as gifts, and through a network of strangers. "By placing 'Wanted' ads in low-end collectible trade papers, I have assembled a corps of dedicated scouts across the nation—a great trawling net of yard sales and thrift shops—that channels me not only to monkeys but also welcome updates on family and health, regional weather reports, and even snapshots of the eye-popping holiday costumes of one Peoria Boston Terrier.[25] Not many new monkeys had entered the collection in recent years, until on-line buying caused a new spurt on acquisitions. Prices are notably higher now, due to the expanded competition of this new market place.

The one hundred sock monkeys selected for this exhibition were chosen with endurance in mind: they had to travel well. This meant no felt (which frays), no loose attachments (which could get lost), and no inherently fragile monkeys (some in the collection are quite old and delicate). These restrictions were hardly limitations, however; there were still plenty to choose from. Surveying those on view, it is amazing to see the basic instructions yield such variation.[26] The pattern calls for a cap, but many are fully clothed or in costume. There are Christmas elves and clowns, rich and ragamuffin monkeys, and monkeys dressed as Uncle Sam. Couples crop up in coordinated outfits—there is a duo in Western wear (a simian Roy and Dale Evans). There are fanciful individuals: a dapper monkey in striped silk pants and a fez. Their

paws can be ornamented with bells, jewels, pom-poms, ribbons. Stuffing gives shape to a host of monkey morphologies, from chubby to trim, from lumpy to saggy to firm.

The inventive aberrations are the most interesting. A very old monkey made from a man's dress sock points to a pre-Red Heel phase of the toy's evolution. The heel that makes such a nice mouth sometimes turns up as a forehead or a lump on the back of the head. Eyes pop up on the muzzle. Tails sprout from between shoulders. But even when the toys conform perfectly to type, their faces are always unique. And it is these most generic models that best express the standards set by this particular collection—which not every monkey meets. None are cute or doll-like. No matter how elaborate, each retains its essence as a stuffed toy designed to be picked up by its long arms (or tail) and played with. They are dignified by the patina of age, by the signs of stress that come from having been handled and loved, and by the creative accomplishment they modestly represent.

The patent models on view in this exhibition represent a different, less personal manifestation of the collecting impulse. Individual objects here may be visionary, but collecting them was a matter of maintaining a public record and enforcing policy. It was part of the Patent Office's job to keep every model that was submitted to it, as insurance against future claims and submissions. Not coincidentally, patent models tell much about American national identity during the Industrial Revolution. Judging from the breadth of objects under consideration—a lard lamp, a camera, a dog-powered treadmill, a pill-coating machine—entrepreneurial Americans were determined to improve or mechanize every conceivable thing *and* its means of manufacture. Indeed, one of the first museums in Washington D.C. was built to establish and encourage that aspect of the national identity known as Yankee ingenuity. Located in what is today the National Portrait Gallery, this museum housed the U.S. Patent Office's display of models and was a thriving tourist attraction during the late nineteenth century. But in less than fifty years, the collection's popularity was overwhelmed by the huge public expense required to store and maintain it. What's more, the inventory was constantly outdating itself, and in 1880, printed patents made patent models (and the handwritten documents that accompanied them) obsolete.

The patent models selected for this exhibition were chosen for their interest as objects, rather than their relevance to the history of technology. George F. Lampkin's wire igloo of an animal trap appears handmade, perhaps by the inventor himself. James Perry's little sewing machine, with a golden horse attached to the body and its exquisite metal mechanisms, suggests the work of a professional model maker whose business no doubt thrived during the Industrial Revolution. Since the models were destined for public exhibition, inventors were eager to make a good impression. Haro J. Coster of Chicago, Illinois, proudly advertised his

name and address in gold lettering across the back of his miniature rocking chair with built-in fan. The appeal was intentional. Curator Barbara Janssen observes that "many put extra effort into making them attractive. These models therefore represent the attempts of their designers to communicate a typically nineteenth-century sense of the aesthetic quality of technology."[27] Janssen quotes a European visitor to the Centennial Exposition of 1876: "The American invents as the Italian paints and the Greek sculpted. It is genius."[28]

"Novelty, originality, and utility" are what experts looked for in judging a patent, and the same criteria might be applied to the other collections on exhibit here. It's not that a painting by Matthew Ritchie and a sock monkey (both of which are obviously novel and original) would ever function in the utilitarian way that a fire alarm does. But all do fulfill expectations of cultural and aesthetic use, doing whatever it is art and sock monkeys are meant to do, and doing it ingeniously and well. In the context of this exhibition, however, we also see how they perform the at once highly complex and simple task—shared by every object on view—of being part of a collection. While we may not share the possessive passion each collector feels for his or her (or its) elected object of desire, we can share the passion that goes into the collecting of it. Indeed, we may not be able to help ourselves.

A curator, writer and art historian, Ingrid Schaffner curated many exhibitions independently, among them Deep Storage: Collecting, Storage, and Archiving in Art. *She is now the adjunct curator at the Institute of Contemporary Art, University of Pennsylvania, Philadelphia. Ms. Schaffner has written extensively on art and is the co-editor of the quarterly publication* Pink.

NOTES

1. Walter Benjamin, "Unpacking My Library: A Talk about Book Collecting," *Illuminations*. New York: Schocken Books,1968, pp. 59-67.

2. Benjamin, p. 60.

3. Benjamin, p. 59.

4. "Suffice it to quote the answer which Anatole France gave to a philistine who admired his library...'And I suppose you have read all these books, Monsieur France?' 'Not one-tenth of them. I don't suppose you use your Sèvres china every day?'" Benjamin, p. 62.

5. Bruce Chatwin, *Utz*. New York: Penguin Books, 1988, p. 20.

6. Isabel McDougall, "An Artist's House," *The House Beautiful*, September 1902, p. 199.

7. George Peak, B.S.E., "Does Your Child Collect? Make the Habit of Value to Him," *The Delineator*, February 1919, p. 40.

8. An Egyptian dream oracle sat prominently on Freud's desk, and he owned several representations of Oedipus, after whom he named one of psychoanalysis's most infamous complexes. cf. Stephan Salisbury, "Dr. Freud's Collection, Objects of Desire," *The New York Times*, September 3, 1989, p. H, 24.

9. Guy Pène DuBois, "The Art Treasures of an American Collector: Pictures and Tapestries in the C.K.G. Billings Collection," *Arts and Decoration*, December 1912, p. 47.

10. J.J. Pollitt, *The Art of Rome c. 753 BC to 337 AD:*

Sources and Documents. Englewood Cliffs, New Jersey: Prentice Hall, 1966, p. 77.

11. Ivor Smullen, "You Must See My Collection," *The New York Times*, February 13, 1987, p. I, 33.

12. Kenneth S. Breecher, *Too Sad to Sing: A Memoir with Postcards*. San Diego: Harcourt Brace Jovanovich, 1988, p. 2.

13. Malcolm N. Carter, "The Magnificent Obsession: Art Collecting in the 70s," *ArtNews*, May 1976, p. 44.

14. David Owen, "The Sultan of Stuff," *The New Yorker*, July 19, 1999, pp. 60–61. Shear's immense and ever-growing collection is an industry in itself: objects are rented out for display and research purposes, exhibitions are organized and toured.

15. Adele Freedman, "Collector Joseph Tannenbaum: 'Joey is Like a Hunter,'" *ArtNews*, February 1981, p. 120.

16. Fred Ferretti, "The Collecting Compulsion," *The New York Times Magazine*, July 27, 1980, p. 24.

17. There are even things made for no other purpose: collectibles. These soul-less objects (where are the appeals of rescue, touch, time?) first appeared on earth in 1895 when the Danish concern of Bing & Grondahl issued their limited edition *Behind the Frozen Window* Christmas plates.

18. Frank Hermann, *The English as Collectors*. New York: W.W. Norton & Co., 1972.

19. Kyle Husfloen, quoted in Fred Ferretti, p. 25.

20. After Finley was vilified in the national press as a "chocolate-smeared young woman," she became one of four artists who were denied the grants awarded them from the National Endowment for the Arts. Acts of censorship and protest against "the NEA Four" resulted in the NEA's current ban on grants to individual artists.

21. Green's sculpture is an accurate representation of an actual pipe bomb in every way, save that it doesn't have gun-powder in it. In legal terms, this detail means it is not categorized a "weapon" but as a "model"—an interesting point in the context of this exhibition of pictures and patents.

22. A number of works were selected with the other components of this exhibition in mind. Charles LeDray's *Bear*, 1992 (page 18), is a lovingly handmade sculpture of a deformed stuffed animal. Carrie Mae Weems's text-based work tells a Black American legend of a monkey. The spirit of invention is evident in, among others, Willie Cole's *Wind Mask* (made of recycled hairdryers), 1991 (page 14), and Paul Ramirez-Jonas's *Hexagonal Box Kite after Alexander G. Bell*, 1993 (page 20), a sculptural contraption for taking one's picture from the air.

23. All Shiffler quotes from his statement in *Mettlesome & Meddlesome: Selections from the collection of Robert J. Shiffler*. Cincinnati: The Contemporary Arts Center, 1993. Discussing motives, he notes, "In the beginning, I was attracted to the social status afforded 'art collectors,' and like most people, I wanted to establish my identity."

24. For obvious reasons, this performance relic could not be included here. Tiravanija's work is represented by *Untitled (Apron and Thai Pork Sausage)*, 1993 (page 22), the proper display of which calls for cooking and serving said sausages. Another complex work at the Shiffler Foundation, as challenging to own as it is to exhibit, is Gregory Green's *Work Table #4*, 1994, a room-sized installation crammed with the tools, tables, and trappings of a bomb-maker's lair.

25. All sock monkey quotations are from Ron Warren, "The Sensational Red Heel Sock Monkey," *Pink*, Vol. I, no. 4, 1995–96.

26. In 1958 the Pack-O-Fun Company published a how-to book of Red Heel Sock Monkey toys. Some of the variations, including sock elephants, are included in this collection. In general, however, the collection avoids such curiosities and sticks to monkeys.

27. Barbara Suit Janssen, *Icons of Invention: American Patent Models*. Washington, D.C.: National Museum of American History, Smithsonian Institution, Washington, D.C., 1990, p. 13. I am indebted to Janssen's catalogue for its insightful history and overview of the patent model collection.

28. Janssen, p. 18. Janssen cites this quote as an "oft-recited observation in the late nineteenth century, one usually attributed to a European observer at the Centenntial [sic] Exposition of 1876."

THE NATIONAL MUSEUM OF AMERICAN HISTORY

The National Museum of American History, one of many divisions of the Smithsonian Institution, holds nearly 10,000 patent models, the largest and most comprehensive such collection in the world.

In one of its first acts of government, the U.S. Congress instituted a patent system that deviated from the English system in one crucial respect: along with the customary written description, applicants had to submit a three-dimensional model. In her book on patent models, Barbara Suit Janssen of the Smithsonian writes: "Before 1790, state and colonial authorities often granted patents or patent-like monopolies for inventions which subsequently turned out to be no more than impractical dreams. To protect the public from such useless and cumbersome monopolies, these authorities eventually began to require models from petitioning inventors as evidence of the operability of their inventions." Early on, the focus shifted from feasibility to communication. A model didn't necessarily have to work, but it did need to represent what was described in the written patent, which was typically mired in technical language incomprehensible to the officials and jurors who might be called upon to judge its claims.

In the 1920s, the federal government decided to disband the U.S. Patent Office's collection of models and offered the Smithsonian Institution its pick of the lot. The objects date from 1836 (a fire at the Patent Office destroyed earlier models) to 1880, from which time on only written patents were accepted. From the 150,000 available objects, the Smithsonian chose about 10,000. The rest were sold, mostly at public auction. Those selected by the Smithsonian were consigned to the National Museum of American History, where they were dispersed among various museum departments, according to their relevant technologies. Jabez Burns's adding machine, for instance, is now in the Mathematics Collection; Montague Redgrave's bagatelle is in the Division of Cultural History; Dexter Pierce Sunapee's clothespin is in Textiles. —I.S.

Patent models in storage at the
National Museum of American History,
Smithsonian Institution, Washington,
D.C. Their sizes range from
approximately 8 x 8 x 5 inches to
approximately 15 x 15 x 12 inches.

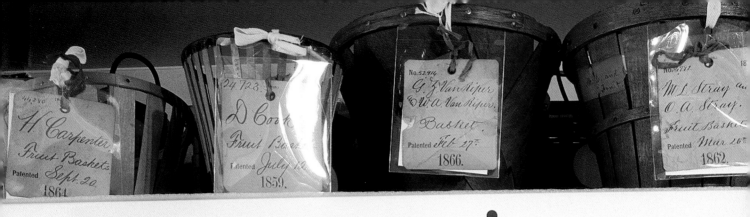

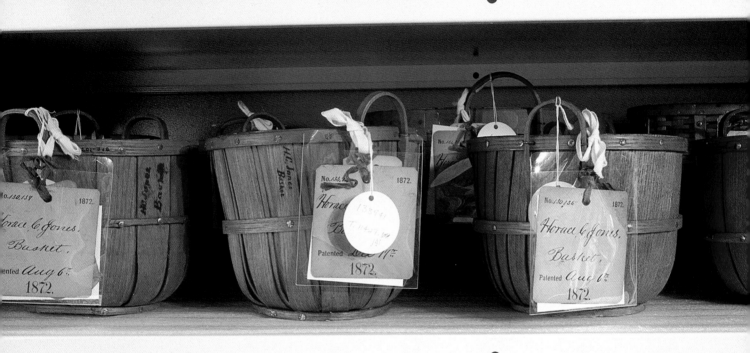

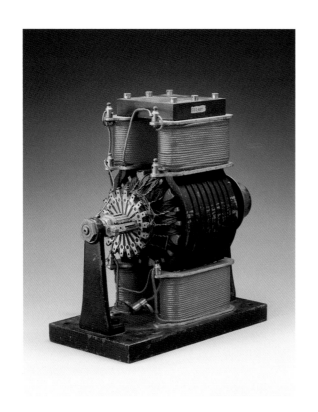

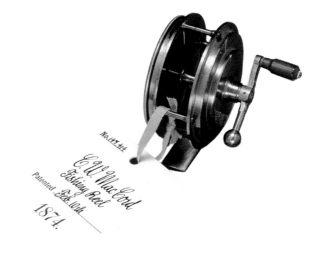

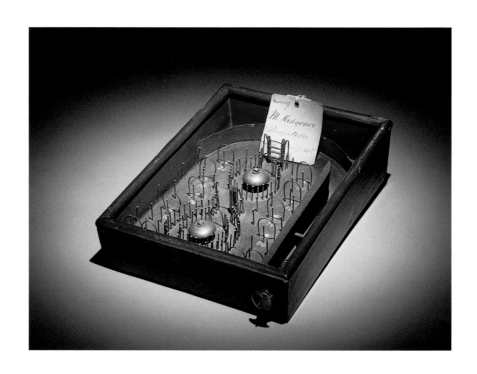

Electric Generator
HIRAM S. MAXIM
Brooklyn, New York
November 2, 1880
Patent No. 233942

Fishing Reel
CHARLES W. MacCORD
Weehawken, New Jersey
February 10, 1874
Patent No. 147414

Bagatelle
MONTAGUE REDGRAVE
Cincinnati, Ohio
May 30, 1871
Patent No. 115357

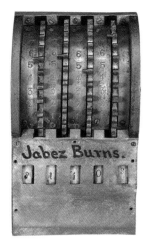

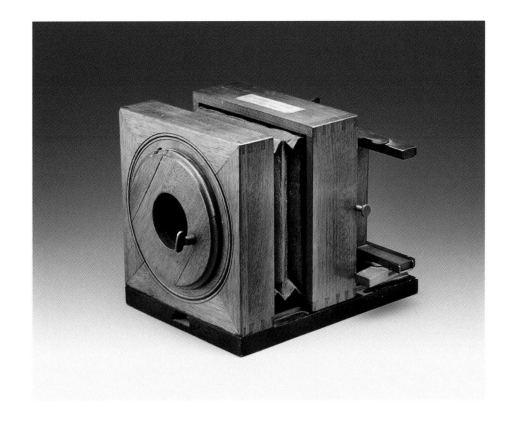

Combination Tool
JOHN GRAHAM
Ludlow, Vermont
November 5, 1867
Patent No. 70547

Adding Machine
JABEZ BURNS
New York, New York
August 24, 1858
Patent No. 21243

Camera
JOHN STOCK
New York, New York
July 5, 1859
Patent No. 24671

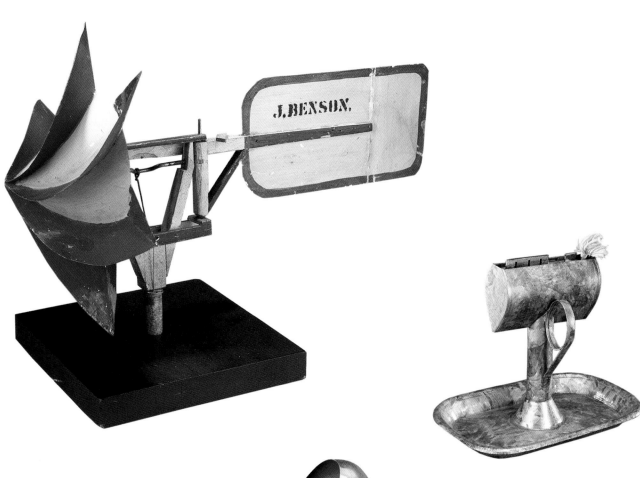

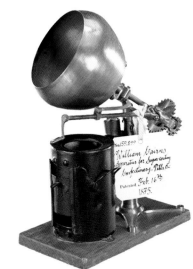

Windmill
JESSE BENSON
Champaign County, Ohio
November 12, 1878
Patent No. 209853

Lard Lamp
DELAMAR KINNEAR
Circleville, Ohio
February 4, 1851
Patent No. 7921

Pill-Coating Machine
WILLIAM CAIRNES
Jersey City, New Jersey
February 16, 1875
Patent No. 159899

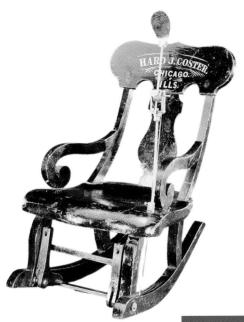

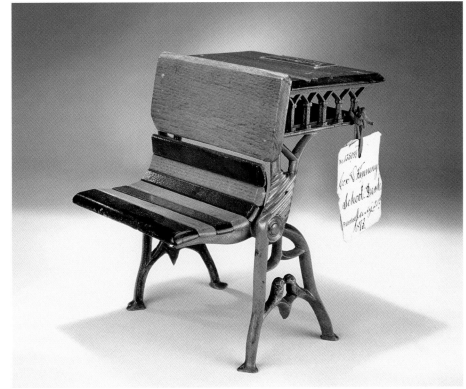

Rocking Chair with Fan
HARO J. COSTER
Chicago, Illinois
May 8, 1860
Patent No. 28159

School Desk
SYLVANUS COX &
WILLIAM FANNING
Richmond, Virginia
January 21, 1873
Patent No. 135089

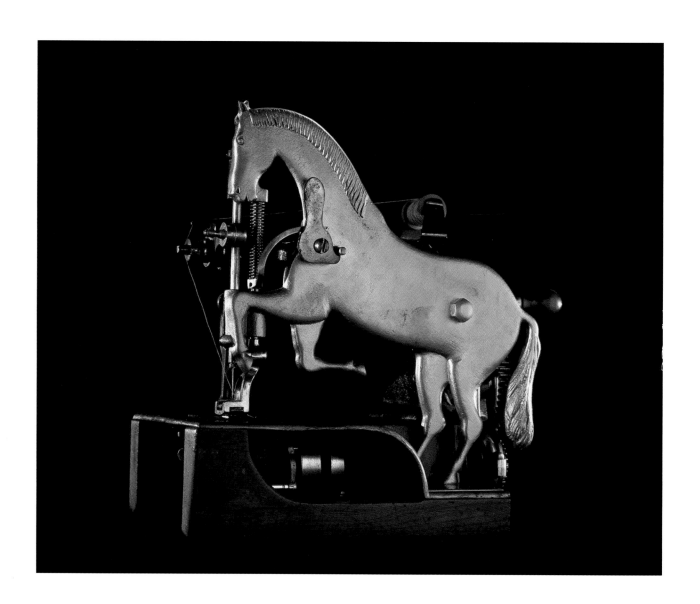

Sewing Machine

JAMES PERRY
New York, New York
November 23, 1858
Patent No. 22148

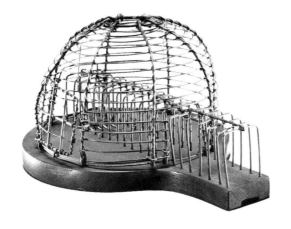

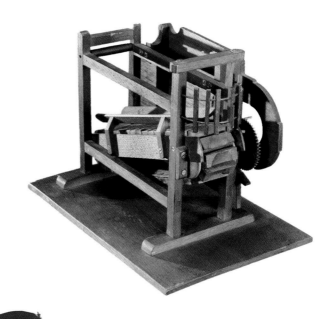

Animal Trap
GEORGE F. LAMPKIN
Georgetown, Kentucky
July 9, 1872
Patent No. 128802

Dog-Powered Treadmill
FREDERICK H. TRAXLER
Dansville, New York
April 23, 1878
Patent No. 202679

Saddle
GEORGE HORTER
New Orleans, Louisiana
July 5, 1870
Patent No. 105080

Clothespins

DEXTER PIERCE
Sunapee, New Hampshire
May 28, 1858
Patent No. 20364

JEREMIAH GREENWOOD
Fitchburg, Massachusetts
November 15, 1864
Patent No. 45119

HENRY W. SARGEANT, JR.
Boston, Massachusetts
April 11, 1865
Patent No. 47223

T.L. GOBLE
Orange, New York
December 18, 1866
Patent No. 60627

DAVID M. SMITH
Springfield, Vermont
April 9, 1867
Patent No. 63759
(not in the exhibition)

A.L. TAYLOR
Springfield, Vermont
April 7, 1868
Patent No. 76547

HENRY MELLISH
Walpole, New Hampshire
October 17, 1871
Patent No. 119938

VINCENT URSO &
BENJAMIN CHARLES
Evansville, Indiana
August 12, 1873
Patent No. 141740

RICHARD B. PERKINS
Hornellsville, New York
February 20, 1883
Patent No. 272762

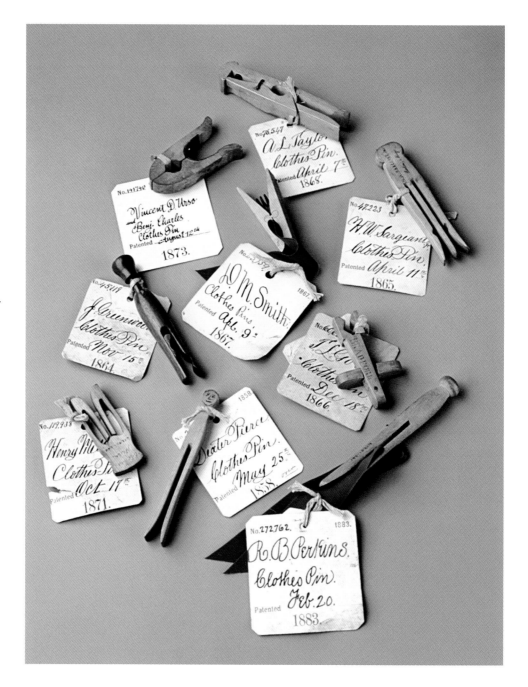

FRED WILSON

mining the museum in me

In my travels around the world, I have had the opportunity to explore the basements and attics of many museums. These forays have afforded me a unique view of the passion of collecting, and I have been able to compare practices of different museums, countries, cultures, and eras. When I scour the shelves of these institutions, what fascinates me is not the latest innovation in museum furniture or storage systems, or even the art and objects collected. I am interested in what the collectors, curators, and keepers seem to have felt about the things they collected, given how they displayed and stored their treasures and "oddities," and described them in their ledger books. It is probably most accurate to say that I collect the collecting habits of others. Key to my investigations are the visual manifestations surrounding a collection—museum architecture, display and storage, graphic design developed for the institution, and vernacular design developed unintentionally over the years by staff and visitors. As a visual artist this is a language I understand.

In the British Museum's Egyptian collection, I found an ancient stone fist encased almost entirely in cement. The cement was used as a display mount, and was an overly protective—

and destructive—exhibition device. But I saw it, above all, as a metaphor for British colonial control of Egypt. In an American museum, I found an African mask with large, gaping holes. Perpetrated at least eighty years ago and clearly not put there by the maker, the holes were a previous curator's solution for attaching the piece to a gallery wall. To me they indicated a lack of respect not only for this art but for all of Africa and its inhabitants.

As a child I collected bottle caps. I had a huge number of them in the bottom drawer of my desk in my room. I found them everywhere—on the sidewalk, in the park, in the schoolyard, and in the woods behind our house, as well as in the kitchen. This was a solitary endeavor. I would take them out and marvel at their graphics, source, use, and age, noting the rare ones and the damaged ones, but saving them all. Today I am no longer interested in being a collector—at least I don't have the overwhelming desire to own a lot of one type of thing. I do have a small collection of globes, each bought for twenty dollars or less; books on pre-colonial Africa and on museums; and hand woven fabrics from the places to which I've traveled. I think I actually fear collecting now, because most objects and images scream out to me to be understood. I want to save them, to commune with them, to have them all. A piece of mass-produced detritus may have more meaning for me than the most expensive and rare item, and I value meaning more than money. Sometimes I buy things that annoy me, or things that I feel are overlooked or misunderstood. But I collect them only in order to make artworks—as a way to unravel the mystery of my feelings and society's feelings about them. Most of the time, once I've re-contextualized these objects, they go to collections or into storage; they don't stay in my studio.

It is fascinating to see what happens when my own work is collected. It has been my experience that when art joins a collection it shifts meaning and becomes more about the collector than about the artist. This is especially the case if the work is displayed in the collector's home. Once a piece of mine was sold at a museum auction after a fierce and expensive bidding war. With the body of Hermes and the head of Anubis, the sculpture commented on the relationship between ancient Greece and Egypt, and between contemporary people of European and African descent. But the collector enthusiastically exclaimed, "I love the sculpture; it looks like my dog!" I have at times come across my work at parties in the homes of wealthy people; misplaced and mute as a stuffed bird or bear, it seems to function there as a trophy acquired in a foreign land, as if it had been bagged during an art safari. In an interior design magazine I once found photographs of a princess's fabulous home. To my surprise, each room featured photographs of mine. These photographs, however, are intended to hang together; their full meaning is elicited by their juxtaposition. Arrayed as they were around the house, they became nothing more than pretty pictures. It was as if a debate was taking place between a decorator, say Martha Stewart, and me—instead of between the images themselves—and Martha was winning.

When race enters the picture the context can get particularly charged. I once had to stop a well-meaning European curator from putting one of my photographs of a mammy cookie jar on the cover of an exhibition catalogue. This group show of the works of black artists, *Postcards From Black America*, was to travel around Europe. My photograph was mural-sized; the scale as well as the image itself were meant to convey sadness and heroism. Reducing it to the size of the catalogue and emblazoning the title of the exhibition across it would have reinscribed the stereotype I hated, negating the complexity I had hoped to reveal. When my photos and sculptures of mammy and pappy salt shakers and cookie jars are displayed individually, either in non-thematic museum exhibitions or in collectors' homes, they take on institutional or individual perspectives, including racist viewpoints. Viewers often assume that since the museum staff or collector is white, the artist is as well, and work that is about a struggle to understand one's own identity in the face of a racist world can become an unambiguously racist statement.

When I see my work in a major collection I am thrilled. But I am also conflicted. As a decipherer of display, I know that my own work—now untouchable in a glass display case—is also no longer mine. When I come across my art in this context, I almost don't recognize it. In a sense, it has lived in another world for so long that it no longer speaks my language. As in *Pygmalion*, the transformation has concealed its roots.

Fred Wilson is an artist whose practice often focuses on collecting, with an early one person exhibition at Maryland Historical Society jointly sponsored by the Contemporary Museum in Baltimore, entitled Mining the Museum *(1992). His work has been shown in exhibitions at numerous museums since, among them the Museum of Modern Art, New York. Mr. Wilson has received many prizes, including the John D. and Catherine T. MacArthur Foundation Award in 1999.*

THE PRIVATE COLLECTION OF
SOCK MONKEYS

Sock monkey toys have been a popular handicraft of the American Midwest since 1953, when the Nelson Knitting Company of Rockford, Illinois, first published directions for turning a pair of cotton socks into a stuffed toy. In the same year, the company patented its design for a red-heeled sock, and it is this heel which gives the monkey its characteristic grin. Considering what a humble homemade toy it is, the original sock monkey seems to speak less to children of post-war prosperity than to the nostalgia of their parents who grew up during the Depression. The private collector who owns the sock monkeys in this exhibition belongs to neither group, but to the generation of the 1960s, many of whom do not even know what a sock monkey is. As he has explained in an essay on his collection, "My own reacquaintance with the sock monkey occurred more than ten years ago when a friend [...] presented me with one he had purchased at a rural airport's handicrafts shop. Its appeal to him was empirical—he had no knowledge of its peculiar genesis or cultural bearing." He then launched the collection, in 1985, to demonstrate the historic existence and downright ubiquity of these toys—a point this fantastic assortment of sock monkeys has now more than proved.

 The collector tags each new acquisition with a number and records it in a log book, noting the toy's cost, provenance, and some identifying features. There are codes for common features, such as black stitched eyes, lashes and noses ("bl st eln") and to indicate where the tail is attached. The collection now numbers almost 2,000 objects, all stored in cardboard boxes. —I.S.

Sock monkeys "at home"

The following pages feature some of the sock monkeys in the exhibition. The monkeys with the following identification numbers are included in *Pictures, Patents, Monkeys, and More*: Sock monkeys no. 1322, 1323, 1338, 1344, 1345, 1349, 1350, 1361, 1366, 1374, 1380, 1383, 1387, 1397, 1398, 1403, 1408, 1409, 1503, 1505, 1507, 1508, 1509, 1511, 1518, 1519, 1520, 1524, 1528, 1529, 1532, 1536, 1540, 1541, 1545, 1546, 1549, 1552, 1556, 1560, 1562, 1564, 1567, 1568, 1570, 1571, 1581, 1585, 1587, 1589, 1591, 1596, 1601, 1604, 1605, 1606, 1607, 1609, 1610, 1612, 1614, 1615, 1620, 1622, 1623, 1625, 1627, 1630, 1631, 1632, 1636, 1637, 1641, 1643, 1645, 1649, 1650, 1651, 1653, 1662, 1663, 1670, 1673, 1680, 1682, 1692, 1693, 1694, 1697, 1699, 1700, 1705, 1706, 1710, 1711, 1712, 1717, 1718, 1724, and 1725.

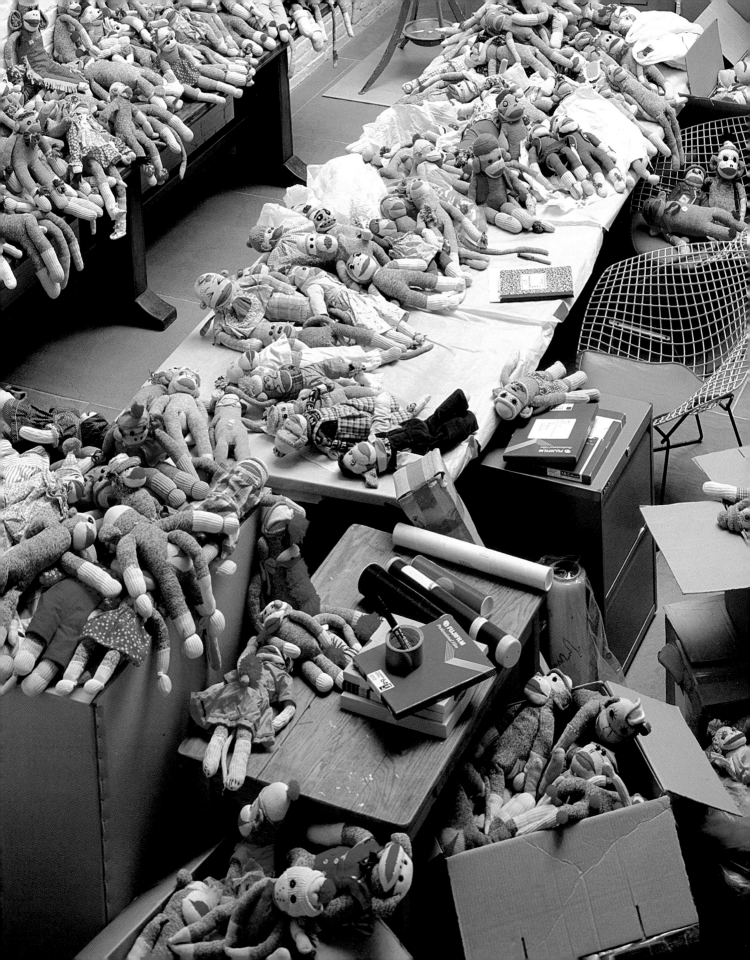

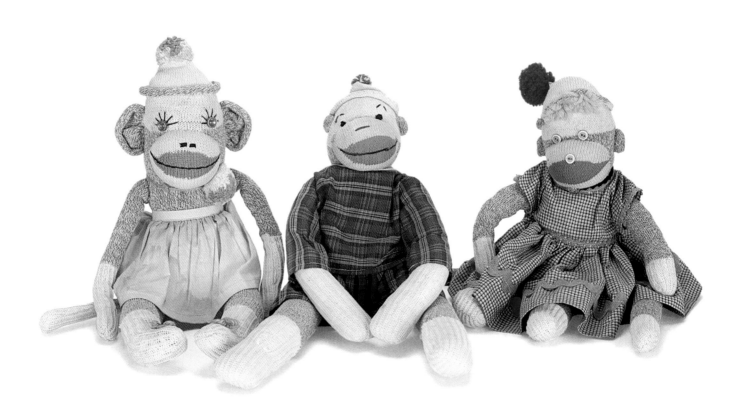

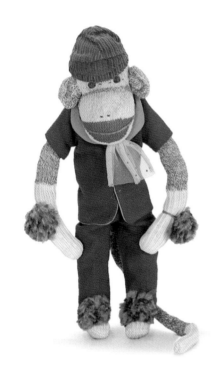

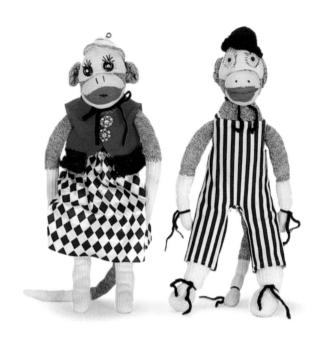

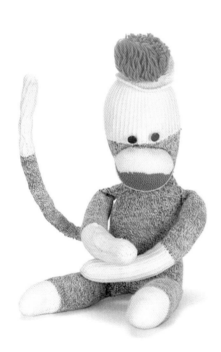

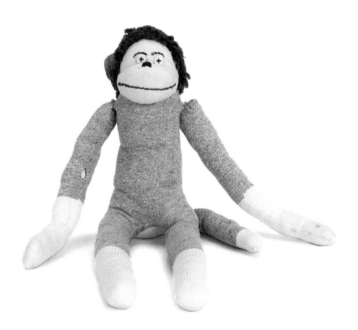

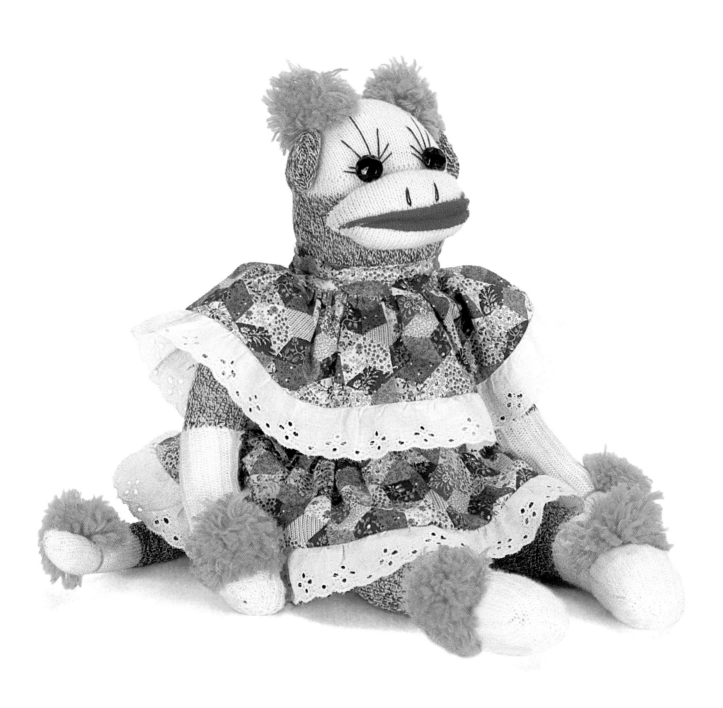

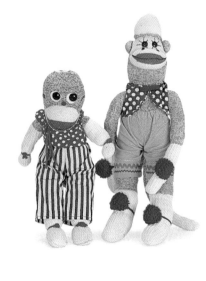

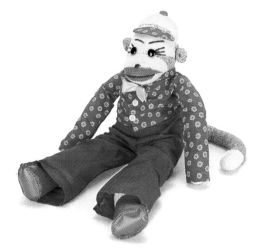

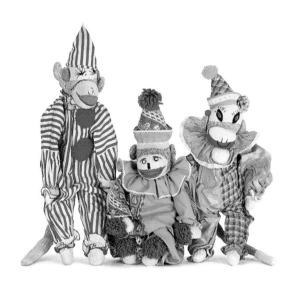

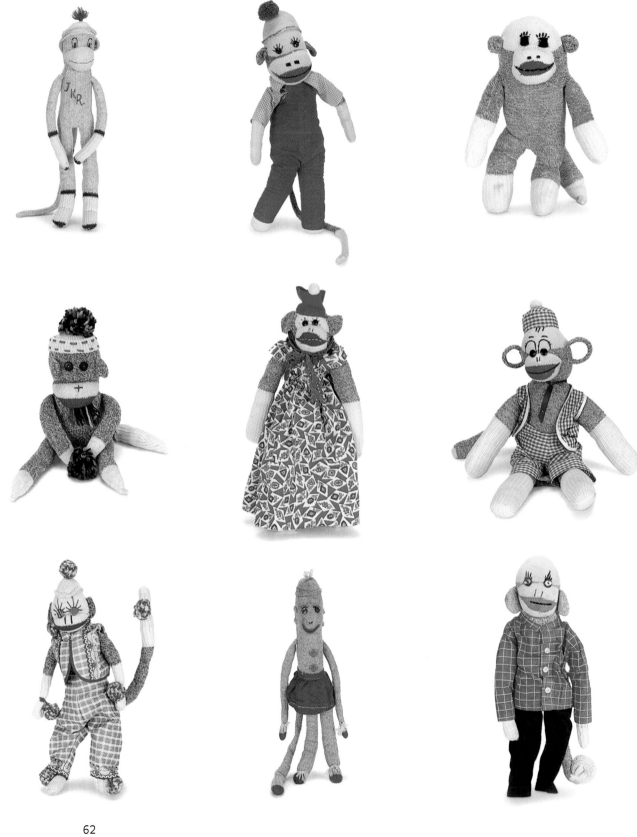

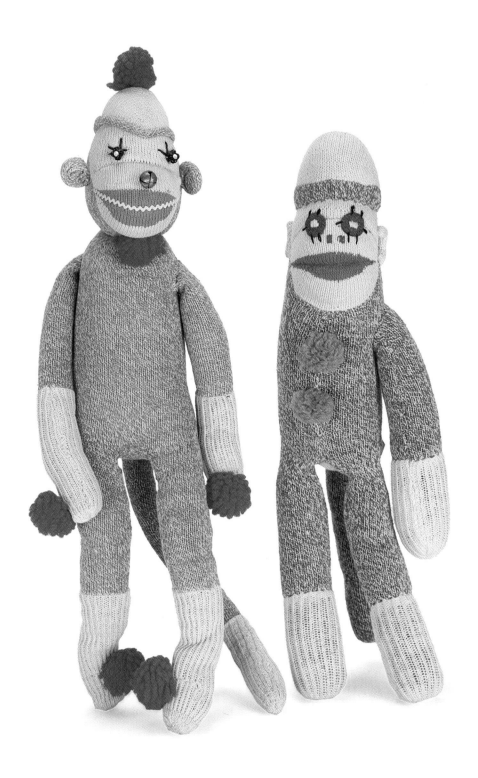

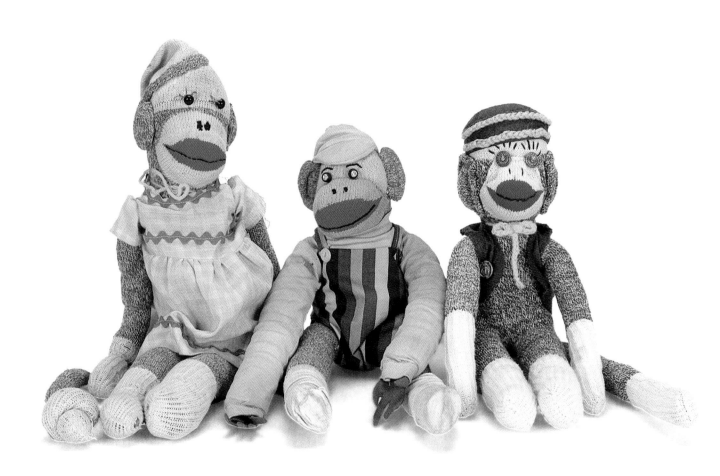

WERNER MUENSTERBERGER

the quest for possessions

In December 1902, an enterprising young American in England, well-to-do and with a keen eye for art, was the guest of another expatriate American, Bernard Berenson. Leo Stein was on his way to Florence and was planning an extensive study of Mantegna; he wanted to consult Berenson, who was already considered a respected historian of Italian Renaissance art. Stein also wanted to visit Paris, and in that connection Berenson told his younger friend to pay attention to the work of a contemporary painter by the name of Paul Cézanne.

Instead of pursuing his original plans, Stein remained in Paris and acquired a painting by Cézanne. This purchase was followed by another, a painting by Henri Matisse. He was soon joined by his younger sister, Gertrude, and eventually abandoned his plans to study Renaissance art in Italy. The two became devotees of contemporary art, and close friends with a number of artists, including Juan Gris, Pablo Picasso, Fernand Léger, and Georges Braque. The young Americans also supported this work with generous purchases. "Between 1905 and 1907," John Richardson writes in his admirable biography of Picasso, "Leo was

unquestionably the most adventurous and discerning collector of twentieth-century painting in the world." And Gertrude Stein understood, applauded and promoted these young painters' daring new language. These collectors and artists shared a set of aesthetic perceptions and values, as well as social and intellectual concerns—all of which fostered a spirit of solidarity among them. But collecting is more than just an intellectual or aesthetic endeavor, it is an emotional and sensory experience.

Gombrich has pointed out that the observer of art "will always project some additional significance [onto the work] that is not actually given. Indeed we must do so if the work is to come to life for us." There is no doubt that the same can be said for virtually all kinds of collecting. Most people who are moved by and enjoy or admire a painting or sculpture are satisfied by seeing it in a museum or in an exhibition such as the present one. But there is a silent communication between the art object and a collector. I have often heard collectors say, "It talks to me," to explain their likes and dislikes of objects—a phrase that points to an individual, affective dialogue. (To understand this phenomenon one need only observe a collector with a cherished object, in silent conversation with it.) Collectors may be moved, aroused, or affronted by the object, but they are always in some way affected strongly by it, or by the theme or issue it depicts. These observers want more than to see a work in a public exhibition. They want to possess it, and not for economic reasons. For them the knowledge that they possess the object is a profound, all-encompassing experience. As Walter Benjamin, one of the twentieth century's most perceptive essayists and himself a dedicated collector of books, understood, "ownership is the most intimate relationship one can have to objects. Not that they come alive in him; it is he who lives in them."

The idea of intimacy brings me to the title of this essay. To me, "quest" alludes to a romance and to a uniquely human and usually personal experience of search. There is a tension in this sort of seeking, an anticipation that is rarely shared with others. A woman of my acquaintance once saw a beautiful antique tapestry in an art gallery, which she wanted and had the means to acquire. But since she was by nature indecisive, she hesitated to buy it and questioned its actual value, its significance. The more she hesitated, the more she also chastised herself for being unable to decide. So she sought the advice of one or two experts, who were inclined to suggest that she make the purchase. When she returned to the gallery to discuss the sale she was informed that it had been acquired by a local museum. "I lost it," she said to me, in tears. After a moment, I asked: "How can you loose something you did not even own?" And trying to comfort her, I added: "After all, you can see it any day in the museum." "That's not the same," she replied. Her sorrow came from the fact that she felt she could not possess what she had already fantasized as belonging to her.

Meeting dedicated collectors and recognizing the importance they bestow on their possessions—above all other interests—one wants to understand their longing and need. People have their tastes and preferences. They have passions and enthusiasms—usually quite focused and often absorbed. But collectors rarely ask themselves why their collection (or, from our point of view, their habit) occupies such an extraordinary position in their life. This question is fundamental to my approach. I believe that there is an emotional link between collecting and fulfilling earlier needs and cravings. The wish or longing to own or possess an object points to a person's deep-rooted though usually unconscious need to be and remain—and I mean this literally—in touch. This need may go back to earlier contact with a doll, or teddy bear, or any object, as long as it gives his owner pleasure. (Here I must emphasize the expression "it gives," for I see the discriminating collector as the true recipient.) In a more meaningful and deeper sense I am talking about the feeling of companionship. This woman's response invoked the collector's need for ownership and total control of a possession. Yes, she could go to the museum and appreciate the "lost" object. But she could not possess it. (The roots of the verb "to possess" are the Latin verbs posse and sedere, to be able to sit on it.) What she felt was an aspect of experience that bordered on separation distress, caused by a notion of intense aloneness.

Collecting is a chosen pursuit. I have defined it as the selecting, gathering, and keeping of objects of subjective value. Collecting is also a personality trait which tends to express itself in acts, in rituals, in a need to master, even to control, by putting together selected objects according to certain themes or patterns. It is a more or less discriminating enjoyment of "things," whatever the "thing" may be: a relic from a distant past, a Warhol painting, a group of pin-cushions, rare or special books, or stuffed animals. People who collect always have their own private point of view, and the experience and circumstances differ in each individual situation. However, all collecting is a symbolic endeavor to keep in touch, because with loved objects nearby one need not dread being alone. What captivates the dedicated collector has predominantly cultural and environmental roots, while the habit itself goes deeper and is motivated by early, distinctly personal vicissitudes. Inherited objects have rarely the same emotional resonance as those self-chosen, found, or discovered. I have met several people who inherited substantial collections. The late Nelson Rockefeller certainly cared for his entire collection, but his heart was in his self-chosen field of tribal art of the Americas, Africa, and Oceania. This work had a lasting emotional, not material, fascination for him.

Talking with hundreds of collectors of all ages in various countries and continents, it has become clear to me that one cannot isolate this habit from other personality traits. Otto Fenichel, one of Freud's early, leading disciples, argued that "cupidity and collecting mania,

as well as prodigality, have their correlating determinants in the infantile attitude towards feces." Fenichel and several of his contemporaries tried to unravel certain personality traits, among them the powerful inclination to collect and amass. They linked the childhood experience of bowel movement and some children's attempt to prolong or withhold the process of defecation with their inclination to make sand piles, and to assemble toys and other playthings. Later in life this inclination would develop into more grown-up adaptations. Frits Lugt, the famous Dutch collector and cataloguer of Italian, French, and Netherlandish drawings, told me that he started by collecting shells as a young child. Growing up in Holland, close to the North Sea, searching for special shells was a logical choice for an alert young boy. By the age of fifteen, Lugt was already a serious collector of old master drawings.

Human life is deeply anchored in mutuality and dependence, starting with the prolonged helplessness and the related primary emotions of the infant. Anxiety especially during the child's early life can undermine self-confidence, and it is under such circumstances that the child finds relief by turning to toys and other inanimate objects. I have met collectors who during their childhood had been separated from their mother or other need-satisfying persons, and have turned to objects or animals to hold anxiety or feelings of abandonment at bay. Seeing the habit of collecting in this light, one can easily understand that the committed collector is destined to show his inclination quite early, often even during his pre-school days. It is essential to keep in mind that the infant's awareness of being alone is probably never free from the impact of shock and fright. What's more, the attempt to master these feelings is also traumatic, because helplessness renders the individual incapable of preventing it.

I am in agreement with philosopher Susanne Langer. "Man, unlike all the other animals, uses 'signs' not only to indicate things, but also to represent them," she writes. This characteristic is certainly true of all collectors. What people collect is not just the object itself, but is in a profound sense a "signifier" to them. It is clear, when one considers a range of collectors' items (cars, holy relics, fountain pens) that one is looking at a "kind of symbolic process" as much as at a particular object. Today there seems to be no limit to the range of items collected—from Pre-Columbian works of art, to candy wrappings, to Christmas tree decorations, to egg cups from all over the world, to vintage Rolls Royce automobiles—and technological advances have left their mark not only on the kind of collecting we do but on the way we go about searching for special items.

However it is still true that an object or work of art conceived in one's own time and cultural environment is usually easier to respond to than a work created in a different period or under different cultural conditions. In the early 1980s, I visited the twentieth-century descendants of Jan Six, an art lover, collector, and connoisseur who was Amsterdam's mayor

at the time of Rembrandt. There was an almost life-size portrait of Jan Six by the master in their home, and they owned many other works of art from the seventeenth century, but they also had works created during the last hundred years. This wide range of art encouraged me to ask them: "Do you collect, too?" Whereupon one of the sisters responded emphatically: "Of course. The Six's always collected modern art!"—meaning, of course, works created by artists of their times. In that sense, the artworks and the sock monkeys included in this exhibition all fulfill the same psychological function: they root their owners in their cultural environment, allow them to "keep in touch," and prevent that destabilizing sense of loneliness to which I have referred.

Werner Muensterberger is a practicing psychoanalyst based in New York. He has published numerous books and articles on psychoanalysis, in particular comparative psychoanalysis. Among his latest books is Collecting: An Unruly Passion *(Princeton University Press, 1994). Dr. Muensterberger is currently working on a book on the personality of the forger.*

SELECTED FURTHER READING

Anderson, William T., ed. *Mermaids, Mummies and Mastodons: The Emergence of the American Museum.* Exh. cat. Washington, D.C.: American Association of Museums, 1992.

Barker, Stephen, ed. *Excavations and their Objects: Freud's Collection of Antiquities.* Albany, NY: State University of New York Press, 1996.

Benjamin, Walter. "Unpacking My Library: A Talk About Book Collecting" in *Illuminations*. Ed. Hannah Arendt, trans. Harry Zohn. New York: Schocken Books, 1969.

Bloom, Barbara. *The Collections of Barbara Bloom*. Columbus, OH: Wexner Center for the Arts, 1997–98.

Bois, Yve-Alain, Thomas Crow, and Hal Foster. *Endgame: Reference and Simulation in Recent Painting and Sculpture*. Cambridge, MA: MIT Press, 1986.

Bourdieu, Pierre. *Distinction: A Social Critique of the Judgement of Taste*. Trans. Richard Nice. Cambridge, MA: Harvard University Press, 1984.

Buck-Morss, Susan. *The Dialectics of Seeing: Walter Benjamin and the Arcades Project*. Cambridge, MA: MIT Press, 1989.

Cooke, Lynne and Peter Wollen, eds. *Visual Display: Culture Beyond Appearances*. Seattle: Bay Press, 1995.

Corrin, Lisa G. ed. *Mining the Museum: An Installation by Fred Wilson*. Baltimore and New York: New Press, 1994.

Flaubert, Gustave. *Bouvard and Pécuchet*. Trans. T.W. Earp and G. W. Stonier. Westport, CT: Greenwood Press, 1979.

Fraser, Andrea. *Report*. Vienna: EA-Generali Foundation, 1995.

Freud, Sigmund. "Fetishism" in *The Standard Edition of the Complete Psychological Works of Sigmund Freud,* Vol. 21, 1927-31, Trans. James Strachey. London: Hogarth Press, 1953.

Goldwater, Robert J. and René d'Harnoncourt. *Modern Art in Your Life*. New York: The Museum of Modern Art, 1953.

Halle, David. *Inside Culture: Art and Class in the American Home*. Chicago: University of Chicago Press, 1993.

Hiller, Susan. *After the Freud Museum*. London: Book Works, 1995.

Janssen, Barbara Suit, ed. *American Patent Models: Icons of Invention*. Exh. cat. Washington, D.C.: National Museum of American History, Smithsonian Institution, 1990.

Leach, William. *Land of Desire: Merchants, Power, and the Rise of a New American Culture*. New York: Pantheon, 1993.

Lynes, Russell. *The Tastemakers: The Shaping of American Popular Taste*. New York: Dover Publications, 1980.

Marx, Karl. *Capital: A Critical Analysis of Capitalist Production*. Ed. Frederick Engels, trans. Samuel Moore and Edward Aveling. New York: International Publishers.

Mettlesome Meddlesome: Selections from the Collection of Robert J. Shiffler. Exh. cat. Cincinnati: The Contemporary Arts Center, 1993.

MacDonald, Sharon, ed. *The Politics of Display: Museums, Science, Culture*. London and New York: Routledge, 1998.

McShine, Kynaston. *Museum as Muse: Artists Reflect*. Exh. cat. New York: Harry N. Abrams Inc, 1999.

Muensterberger, Werner. *Collecting: An Unruly Passion*. Princeton, NJ: Princeton University Press, 1994.

Nicholson, Geoff. *Hunters & Gatherers*. Woodstock, NY: Overlook Press, 1994.

Pearce, Susan M. *Museums, Objects, and Collections: A Cultural Study*. Washington D.C.: Smithsonian Institution Press, 1992.

_____. *Collecting in Contemporary Practice*. Thousand Oaks, CA: Sage Publications, 1997.

Pietz, William and Emily Apter, eds. *Fetishism as Cultural Discourse*. Ithaca, NY: Cornell University Press, 1993.

Aline B. Saarinen. *The Proud Possessors: The Lives, Times and Tastes of Some Adventurous American Art Collectors*. New York: Random House, 1958.

Schaffner, Ingrid and Matthias Winzen, eds. *Deep Storage: Collecting, Storing, and Archiving in Art*. Exh. cat. New York: Prestel Press, 1998.

Sherman, Daniel J. and Irit Rogoff, eds. *Museum Culture: Histories, Discourses, Spectacles*. Minneapolis: University of Minnesota Press, 1994.

Staniszewski, Mary Anne. *The Power of Display: A History of Exhibition Installations at The Museum of Modern Art*. Cambridge, MA: MIT Press, 1998.

Torchia, Richard. *Field Works: Collecting as Folklore*. Philadelphia: Moore College of Art, (Levy Gallery Brochure), 1989.

Weil, Stephen E. *A Cabinet of Curiosities: Inquiries into the Museum and their Prospects*. Washington, D.C.: Smithsonian Institution Press, 1995.

Weschler, Lawrence. *Mr. Wilson's Cabinet of Wonder*. New York: Pantheon Books, 1995.

Wolff, Purcell, Rosamond and Stephen Jay Gould. *Finders, Keepers: Treasures and Oddities of Natural History*. New York: W.W. Norton & Company, Inc., 1992.